SECRET
PEEBLES

Liz Hanson

AMBERLEY

First published 2017

Amberley Publishing
The Hill, Stroud
Gloucestershire, GL5 4EP

www.amberley-books.com

ISBN 978 1 4456 5924 4 (print)
ISBN 978 1 4456 5925 1 (ebook)

British Library Cataloguing in Publication Data.
A catalogue record for this book is available from the
British Library.

Origination by Amberley Publishing.
Printed in Great Britain.

Introduction

Peebles in the twenty-first century is a thriving town of 8,376 residents (2011 census) and visited by many more for holidays or day trips. For all these people, the location is synonymous with the well-known landmarks of Neidpath Castle, the parish church and the Hydro Hotel, and the walks beside the River Tweed or along the High Street. However pleasurable these are, there is so much more to be seen and discovered, and the purpose of this book is to enhance the experience of Peebles. Of course, in this digital age, very little is 'secret' due to the availability of information on the internet, but, equally, much goes unobserved as the ubiquitous smartphone draws the eyes away from the wider view. The shop windows are certainly enticing but the array of architectural styles above them tell stories in themselves and adornments such as carved trade stones or dated marriage lintels are powerful evocations of past eras.

The epicentre of old Peebles, known as Old Town, is along the elevated ground above Eddleston Water as it reaches its confluence with the River Tweed. On the eastern side is a rocky knoll on which Peebles Castle was built in the twelfth century, used as a royal residence by David I and his guests for the splendid hunting available locally. Half a mile away to the west was St Andrew's Church, founded in 1120 – substantial edifice with a flat-roofed tower and eleven altars. The track between these two places was along the High Street, down Bridgegate, across Tree Bridge, through Biggiesknowe and up the hill through the Old Town. The importance of Peebles was recognised in 1367 when David II granted it status as a royal burgh.

During the fourteenth century pilgrims were travelling to Peebles to visit the Cross Kirk, founded in 1261 after the discovery of relics and an ancient cross. Trinitarian monks (Red Friars) resided there and by 1448 had established a monastery, which existed until the Reformation. The building was then used as the parish church until 1784, after which it was left to deteriorate and stone material was taken to use for other structures. However, Historic Scotland now maintain the ruins and this secluded peaceful enclosure, surrounded by Scots pines, is only a short walk from the High Street.

Incursions into Southern Scotland by the English during the 1500s left Peebles feeling vulnerable, and a wall was built around the town in 1570, parts of which are still visible. These were troubled times: not only had the ecclesiastical centre been overturned, but local lairds were feuding, border reivers frequently stole livestock and the whole rural community became impoverished.

In the middle of the eighteenth century, the Burgh Council began to improve the town physically by levelling the High Street, putting in street lighting, widening Tweed Bridge, providing a water well at the top of Old Town, building a new parish church and demolishing old structures like the Steeple. However, it wasn't until the next century that changes to the way of life began, and they came thick and fast. The coming of the woollen

mills and the railways catapulted Peebles into an era of prosperity and expansion, and although both these industries have passed, the tourist trade, beginning with the attraction of Peebles Hydropathic in 1880, has endured. This book is not a comprehensive history, which has been covered extensively by very able authors, but endeavours to point out some features of the historical span, ranging from traces of medieval Peebles through the turbulent middle centuries to the quirky contemporary.

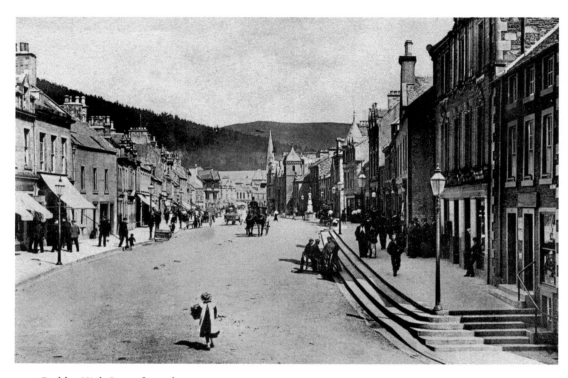

Peebles High Street from the west.

River Tweed

It is possible to stroll across Tweed Bridge in Peebles, admiring the panoramas in each direction without paying much attention to the other people, children, dogs or vehicles that are sharing the space. The width of 40 feet carries two pavements and two-way traffic, so it is hard to visualise the original river crossing of a mere 8 feet, let alone squeezing past a horse or flock of sheep, although Chambers wrote that there were recesses and evidence of a small dwelling with an attached toll house and gate over one of the piers. Drovers in the 1700s complained to the council that their animals were prone to jumping into the river because the parapet was too low. The early history of the bridge is hazy but it is generally agreed that a stone bridge on wooden foundations was there by 1465, at which time the only other bridges over the 97 miles of the Tweed were at Kelso and Berwick, the latter town nearing the end of belonging to Scotland. Tweed Bridge was not widened to 21 feet until 1834 but the burgh records during the seventeenth and eighteenth centuries frequently refer to the cost of repairing the structure. The line of the old stonework can be seen underneath the arches and there is an interesting stone on the western side of the curve nearest the High Street, which is engraved with 'ROUGHLY ... aired July 11 1767' and placed upside down. This was not a date documented for repairing the bridge, but at that time demolition of any building was an opportunity to quarry a supply of building materials, and it had no doubt been recycled. Tweed Bridge was widened to 21 feet in 1834 and a grand ceremony, arranged by the Masonic lodge, took place, culminating in a 'time capsule' being placed in a hole that had been cut in the keystone on the eastern side of the north arch. It contained a copy of *The Scotsman*, some coins and other items of the day. In the old photograph of the pre-widened bridge, a Victorian pissoir can be seen, precariously attached to the northern right-hand corner of the bridge, which was known locally as 'geranium villa'. Between 1897 and 1900 it once again required widening to the 40 foot one used currently; this was when the attractive ornamental dolphin lights were added, although sightings of river dolphins are not one of the secrets of Peebles! The population of the town continues to grow and there have been periodic debates about the possibility of a second road bridge.

A mile downstream from the main Tweed Bridge are the remnants of a private footbridge known as Wire Bridge, which was erected by Sir John Hay, whose estate of Kingsmeadows lay on the south banks of the water. It was marked on the 1857 map but was the casualty of one of Tweed's floods in the 1950s. Wire Bridge Cottage is still inhabited. The Hay family was also responsible for the Priorsford Bridge, opened in 1905. Sir John Hay of Haystoune gifted an area of his land south of the river (Victoria Park) to Peebles in celebration of Queen Victoria's Diamond Jubilee and the suspension bridge linked the recreation ground to the town. The designer was R. J. M. Inglis, who had recently built Tantah House. The other footbridge, upstream in Hay Lodge Park, was

Tweed Bridge, pre-1881, the year the police station was built. Note the pissoir precariously attached in the curve.

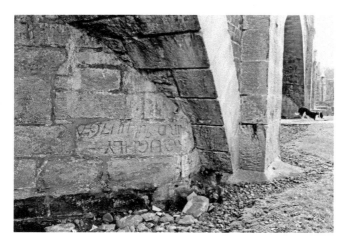

Recycled stone from 1767 in the north arch of Tweed Bridge.

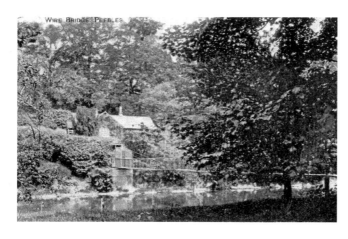

Wire Bridge.

Fotheringham
Bridge.

Ford at Northgate
Vennel.

also paid for by a benefactor, Mr Fotheringham, who had retired to Peebles from South Africa and after whom the bridge is named. The idea of a river crossing at this point may have been spawned in the years between the world wars; the University of Glasgow used Hay Lodge Park for their annual outdoor training camp and the engineers tested their skill by erecting a temporary bridge over the Tweed. One of the architects asked to quote for it was Basil Spence, but it was rejected due to the cost.

In earlier centuries fords were commonplace, a lot of which are still obvious. In the town, the one at the foot of Northgate Vennel across Edderston Water (known as the Cuddy) has a cobbled approach and nowadays is a gathering place for ducks to congregate in the hope of being fed! Less obvious is that of the ford at the foot of St Michaels Wynd, although looking across from there to the foot of Biggiesknowe, there is a gap between the houses where the track emerges at the bottom of the Old Town. At

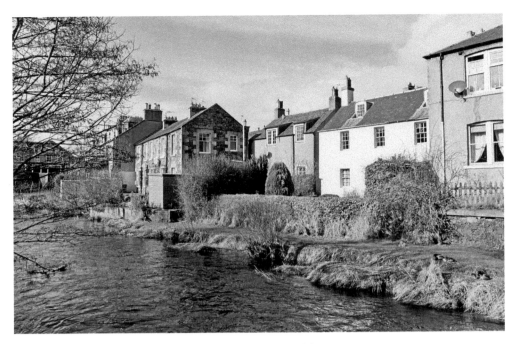

Location of old ford crossing from St Michael's Wynd to Old Town.

the other end of the wynd, on the High Street is the house occupied by Scott Brothers but which, in the fifteenth century, was lived in by a chaplain to the altar of St Michael at St Andrew's Church. He was keen to have an exit made through his back wall so that he could easily reach this ford and the evidence can be seen at the back of the shop where the cobbled area leads to the vennel.

DID YOU KNOW?

Along the east bank of Cuddyside is a stone-built cottage at right-angles to the water. It was originally a smithy but in the early 1980s had an unusual change of use – becoming a GP surgery. The temporary premises were employed between the demolition of the previous surgery at Glencorse House in Northgate (for Fine Fare supermarket) and the opening of the purpose-built Hay Lodge Health Centre in 1983.

There was a stone-clad, wooden, steeply arched bridge over Eddleston Water from the fifteenth century, which is thought to have been called Peebles Bridge (Eddleston Water was then known as Peebles Water). It was cited in 1693 as the place near which a weaver from the Old Town –Thomas Patersone – was drowned as punishment for stealing sheep.

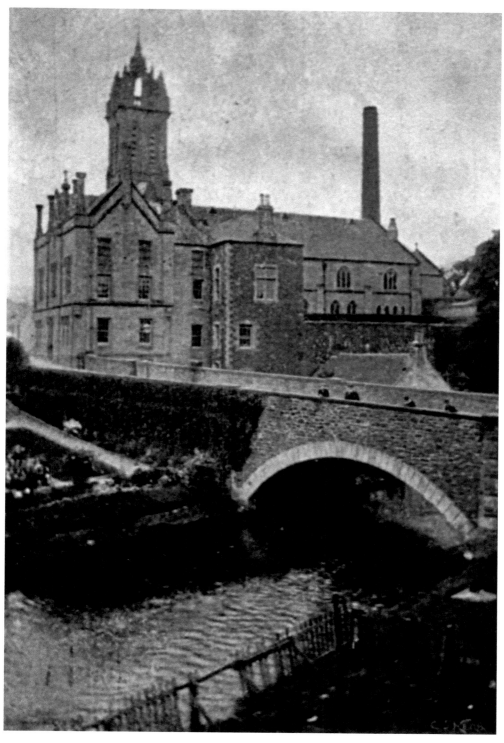

Cuddy Bridge, 1906.

The bridge was in a dangerous condition by 1815 (and by now was being referred to as Cuddy Bridge) but was not repaired until over forty years later, at which time the steep approach was flattened out. Eventually, the entire bridge was replaced with a wider one in 1973, but not without controversy. Initial plans involved completely removing Bank House on the corner of the High Street, which had been the family home of the Buchans and from where Ann Buchan (pen name O. Douglas) had written her books. Local opposition was vehement and new plans were drawn. The compromise agreed upon was the removal of half the house but the retention of the landmark red door, which was put into the west wall. The issue was the catalyst to a Civic Society being created in Peebles.

Prior to the provision of a road to Innerleithen, the next ford downstream was at Cardrona, just below the modern road bridge, and from there the route lay on the south side of the Tweed via Traquair to Elibank. Access to Traquair from the north side of the river was by ferry, the boatman being paid by the Earl of Traquair.

Red door from Bank House, retained after Cuddy Bridge was widened in 1973.

'Boat Pool' on the River Tweed at Traquair.

Widespread bridge building took place in the early nineteenth century but an earlier one was that of old Manor Bridge in 1702, which crossed Manor Water shortly before its confluence with the Tweed, and was paid for by Lord William Douglas, the Earl of March, whose daughter was thought to be the sorrowful 'Maid of Neidpath' about whom Walter Scott wrote. In recent years, old Manor Bridge became unsafe for vehicular traffic but the estate of Wemyss and March have retained their interest in it and in 2015 paid for the bridge to be repaired, although it is only open to bicycles and pedestrians.

Although the river is generally benign, some notable floods have been documented over the centuries. In 1771 the cauld on the Cuddy was washed away and in 1807 Tweed Bridge was damaged by the volume of water, which rose 7 feet above normal levels. The same happened in 1891, when all the wooden bridges in the surrounding area were washed away too. In 1895 extremely low temperatures were experienced across Europe and the Tweed was completely frozen over. Very recently a major project has been completed on the upper reaches of Eddleston Water to help prevent flooding. The watercourse was straightened out when the north turnpike road to Edinburgh was made, and later the railway line was laid on the same route. Meanders have been recreated near Cringeltie and 200,000 native trees have been planted in the surrounding ground. These measures are likely to improve the natural environment and encourage wildlife, as well as slowing the water flow and reducing the flood risk to Eddleston and Peebles.

There had been a cauld on the river since the fifteenth or sixteenth century but by 1726 the council realised it was disintegrating. They sought advice from the Convention of Burghs in Edinburgh, who came with the lord provost to inspect the damage and advised the council that a new one should be constructed on Eddleston Water, just upstream from the confluence with the Tweed, which would increase the water power required by the corn mill below Castlehill, and supplied a grant for the work. The ancient one was left to die, as did the councils' right to it. A century later, when it became apparent that another one was required on the river, not just on the tributary, the council had

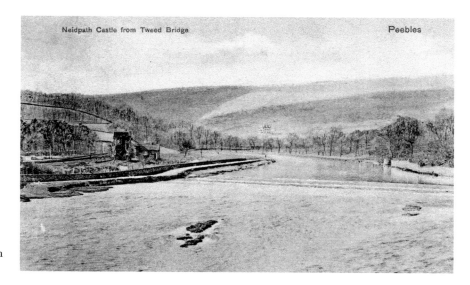

Cauld in 1906.

protracted and difficult negotiations with landowners further upstream, notably the Earl of Wemyss regarding the southern haughland, and Mr Campbell, who owned Hay Lodge. The disagreement dragged on for years until, in 1848, they came to an agreement, which included diverting the lower part of Eddleston Water to join the Tweed below the cauld.

There was certainly no shortage of water in Peebles; the high rainfall in the Tweedsmuir Hills, falling on the boggy ground at its source at Tweeds Well, together with the nourishment from the many burns of upper Tweeddale flowing into it, ensured that. However, harnessing the plentiful resource into a regular, reliable and adequate supply of domestic water proved to be a challenge. The first well was sunk in the High Street outside the Deans House (at a point known as Deans' gutter) in 1728, drawing water from St Mungo's Well, a spring on Venlaw Hill. The cost of this public fountain (£100) was met by John Murray of Philiphaugh, Selkirk, who professed to be very fond of the royal burgh. The Old Town did not have a well until 1780, when one was dug on the corner of Ludgate, which was actually used for over 100 years. As the population gradually increased, the water supply became inadequate, despite a cistern being constructed in Eastgate, and permission was granted in 1813 from Sir John Hay to start drawing water from Soonhope. By 1863 there were seven wells in the town, but still it was insufficient and events moved on apace when Parliament passed the General Police and Improvement Act late that year. The council negotiated with James Wolfe Murray of Cringletie and Lord Wemyss for Meldon Burn to supply water sufficient for a projected number of 3,000 people. Meanwhile, the south side of town was also growing, and despite there being a cistern at Loaningdale, owners of private houses resorted to digging their own wells. In 1885, Manor Water was brought into the equation and water was piped to Bonnycraig. This is the location for the present-day treatment works managed by Scottish Water. In the 1960s the public drinking wells were removed from the High Street but have been retained as decorative artefacts, one in Northgate garden and the other on Tweed Green.

The deposits of sand and gravel around Neidpath Gorge proved to be useful to a local craftsman. Mr Leonard Grandison moved to Peebles from Prestonpans in 1886 and started his ornamental plasterwork business. The firm quickly gained a reputation for their high standard of work, specialising in restoration and creation of ornate ceilings, cornices and centrepieces. The enterprising Mr Grandison realised the benefit of sourcing raw materials so close at hand and approached the Wemyss and March Estates, who agreed to allow him to take as much as he required for a fee of £10 a year. Two boats were purchased for the task, which was only possible when the river level was conducive, and these were moored near the mouth of the Cuddy. Between the world wars, a flood damaged the boats beyond repair, by which time it proved more economical to obtain the materials from nearby quarries than to replace the craft. It is good to know that sand from the Tweed at Peebles found its way into houses as far apart as Strathpeffer and Preston. Leonard Grandison also recalls that his grandfather had taught salmon to jump into his boats – but maybe that is one of Peebles' secrets that is best kept!

The River Tweed is, of course, synonymous with salmon and the Peebles coat of arms depicts one swimming upstream and two returning 'Conta nando incrementum' meaning 'There is growth by swimming against the stream'. The season for fishing these upper reaches is from September to November.

Soonhope Burn,
1903.

Drinking
fountain,
Northgate.

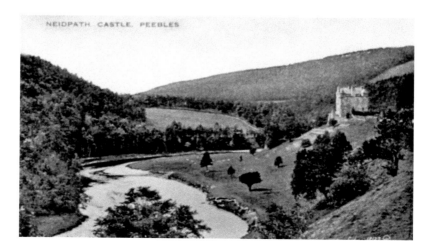

Sandbanks at
Neidpath.

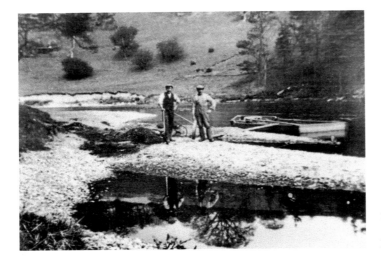

Sand boats in the 1930s.
(Photograph courtesy of
Leonard Grandison)

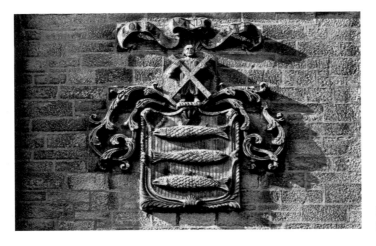

Peebles Arms on the
parish church.

Fishermen in Hay
Lodge Park.

Streets

The layout of Peebles remained unaltered for centuries. It was a small rural community who lived in five streets, three of which – Northgate, Eastgate with High Street, and Bridgegate – were on the peninsular formed between Eddleston Water (originally Peebles Water) and the River Tweed and had been enclosed by a town wall since 1570. Biggiesknowe and Old Town were on the western side of Eddleston Water and led to St Andrew's Church and Neidpath Castle. In the 1600s a visitor to the burgh would have experienced something of the following description. Approaching Peebles from the north, the route was not in the valley but up and down the contours of the hills from Portmore, descending into Peebles from Smithfield Castle, now Venlaw House – a hazardous journey for a carriage or cart that required four horses to pull them up the muddy inclines. Northgate was entered through the North Port, located at the top of Ushers Wynd, and after 100 yards the road turned steeply to the right into Bridgegate, passing the medieval tollbooth at the foot of the brae before crossing Tree Bridge over Peebles Water. Turning left into Biggiesknowe, lined with weaver's cottages, the Old Town dwellings on both sides of the hill until Ludgate were reached at the top. St Andrew's Church lay just beyond on the right, but by this time (post-Reformation) it had been abandoned as the parish church in favour of the Cross Kirk and a track led between the two – although built up now, it roughly followed the line of today's St Andrew's Road and Cross Road. Leaving Peebles to travel west, the route turned sharp right near the gateway to Neidpath Castle up the slope to Jedderfield, then hugged the side of the hill until descending near Edston. Travellers from the Borders in the east first passed the Whitestone, a glacial 'erratic' piece of quartz, which is now displayed in an alcove of the wall on Innerleithen Road opposite the entrance to Peebles Hydro Hotel. In previous times, however, it was a rendezvous point for dignitaries to welcome visitors, where they were given drink from 'the stirrup cup'. In darkness, the white glow from the rock alarmed horses so it was dulled down. The East Port was adjoined by the East Wark, a small watchtower that was demolished in 1656, and having entered through the wall, the Market Cross stood in pride of place at the junction of Northgate, Eastgate and High Street. The fifteenth-century shaft rose out of a 12-foot-wide octagonal building, which had a small side door with inner stairs to access the platform, on which not only did officials stand to make proclamations but also miscreants were made to stand in public view to be humiliated. On the right-hand corner of High Street was a house called the Cunzie Neuk, mentioned as far back as 1473, although later replaced by another one that retained the name. Further down past the single- and double-storey thatched houses with their forestairs protruding onto the road was a low oblong building built at a slight angle to the line of the modern street, namely the Chapel of the Virgin Mary, adjoining the almshouse of St Leonard's Hospital. There was a clock in its steeple, paid for by money from collecting fines. A succession of street

alterations and improvements resulted in the notion that it was lost forever; however, very recently, the cellar under the estate agents office has been cleared exposing a rounded corner of a medieval wall. Rubble was all that was left from the long-abandoned Peebles Castle on the knoll and below Castlehill on the riverside, outside the town wall, was a corn mill. Tweed Bridge was reached by passing through the West Port exit. Between it and the High Street was, and still is, a small cobbled area known as Parliament Square, so-called because it was thought to be the location where the Scottish Parliament met after David II was defeated by the English at the Battle of Neville's Cross in 1346.

Venlaw Castle (previously Smithfield) from Jedderfield.

White Stone, Innerleithen Road.

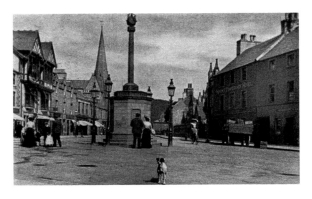

Market Cross and Eastgate, 1903.

Medieval wall below the
High Street.

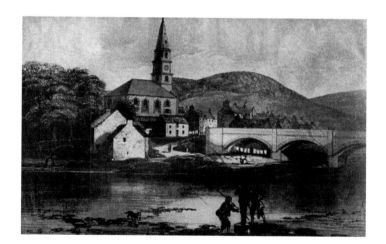

Corn Mill.

The gardens behind the dwellings on the south side of the High Street sloped down to the town wall, which did not reach as far out onto Tweed Green as appears today. The Long Close was a vennel between High Street and the Green and was seemingly a rough part of the burgh, notorious for vagabonds, drunks and dubious ne'er-do-wells; School Brae is a very civilised quarter these days, and is known for the craft shops. Tweed Green was common land where livestock was put out to pasturage and divided by a cauld serving the wauk mill at Walkershaugh. There were no habitations on the land south of the Tweed and the Burgh Muir was where executions took place; there is a modern development of houses called Gallowhill in the vicinity. Beyond here, the drove road went through Glensax and over the hills that were part of the Ettrick Forest, once covered in trees and noted for the good hunting. This ground was in Selkirkshire until 1890 when the Boundary Commission allocated it to Peeblesshire.

By the end of seventeenth century the brutal, violent feuding in the Borders had finally come to an end, and the era of English incursions was over but poverty in the

Backlands of High Street sloped down to Tweed Green. Cabbage Hall at the foot was built outside the town wall.

The hills above Glensax, over which is the old drove road.

whole of Scotland was rife, partly due to successive years of poor harvests but also because of the country's wealth lost in the Darien Expedition in 1698. After the Union of the Crowns in 1707, Peebles, like other towns in Scotland, strove to recover and begin the transition from a medieval town to a more modern one. In the first few decades, the council struggled to contain the number of beggars and strangers coming to the burgh and repaired the town walls, this time to deter vagrants, rather than enemies, from entering, although by 1691 the East Port had been demolished. The royal gloss of earlier times had been dulled by the protracted hardship, and in 1713 the Convention of Royal Burghs granted £100 Scots to the town 'in respect of the low condition of the said burgh'. In 1720, Castle Hill was cleared of the remains of Peebles Castle, the slope planted with trees and the summit of the knoll levelled to create a public bowling green. At this time, there was no public water supply in the town so it was a welcome addition to the High

Street when a water fountain, paid for by John Murray of Philiphaugh, was installed outside the Queensberry Lodging in 1729. Otherwise, the parlous state of council funds prevented any major changes until the middle of the century. During the rebellion of 1745, a contingent of men loyal to Charles Edward Stuart passed through Peebles en route from the Highlands and set up a camp just west of Hay Lodge Park for a few days. They did not pose any danger but the main difficulty was finding sufficient supplies of food to sustain them. In 1752 the dilapidated properties, some inhabited by 'early-day squatters', were cleared away. The property at the top of the close on the High Street was owned by the town clerk, who sold it to the council for £29. On the site they built a new Town House for burgh meetings, the first of which was held on 25 June 1756. These had latterly been held in various places, like the Steeple or chapel buildings because the old tollbooth was ruinous. The architecture was plain but proportionate. In a show of civic pride the Peebles coat of arms adorned the triangular pediment. In complete contrast to our age of transparency, council business, as well as the nomination of Members of Parliament, was done in secret; councillors were required to swear an oath of allegiance to the members that nothing that had been discussed would go beyond the confines of

Hay Lodge Park, previously called Arnotshaugh. In 1745 Charles Edward Stewart's men camped here.

Schoolhouse on Tweed Green.

the chambers, a policy that endured for about thirty years. At the lower end, outside the town wall on Tweed Green, the first school was built in the same year. The next improvement was the removal of West Port and levelling of Port Brae, which included losing another section of the now-redundant town wall, which paved the way for the erection of a the new, but ill-fated parish church on Castlehill in 1780. Four years earlier, the Steeple was demolished and the stones sold to the public. It had outlived its purpose, highlighted by the case of the two men, who, having been convicted of stealing sheep, were sent to the Steeple vaults, but it was so insecure that the council had to buy new locks and hire a guard to ensure the prisoners could not escape. A new prison was built on the north side of Castlehill in 1798. Throughout this period, the council struggled to ensure that there were provisions for the poor. They stopped meal being taken out of the burgh to sell elsewhere, even purchasing bags themselves to offer it to the poor and destitute at a subsided price and, as an indication of how dire matters had become, recommended that these recipients should not keep dogs. 'Meal mobs' frequently gathered to protest at the high cost being charged by the farmers.

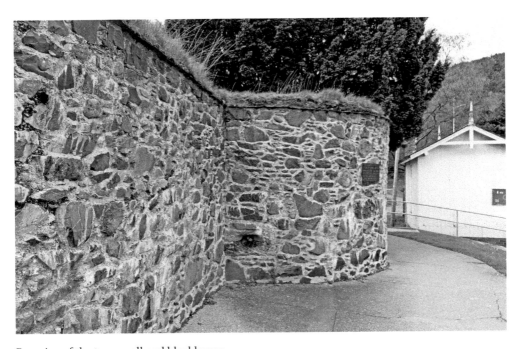

Remains of the town wall and blockhouse.

DID YOU KNOW?

In 1773 there were eighteen oil lamps illuminating the streets of Peebles. They were only lit from twilight until 11 p.m. from mid-October to 1 April, except for eight days of the full moon! Proper gas street lighting was finally installed in 1828.

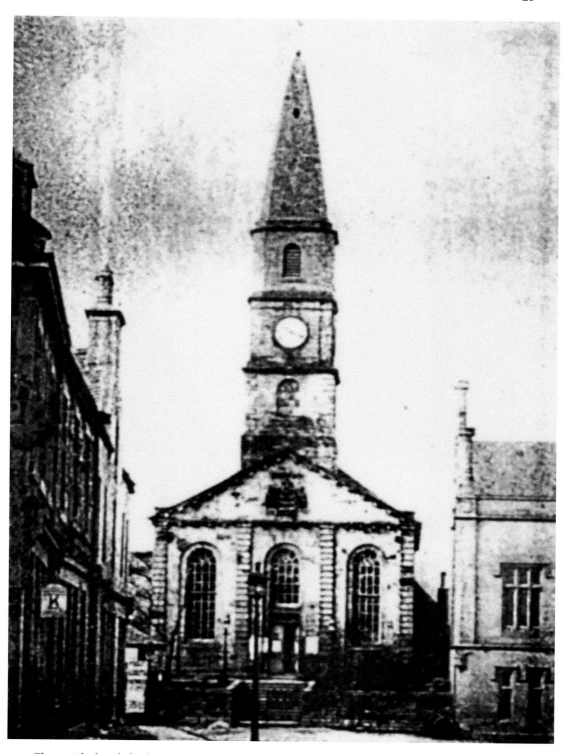

The parish church, built in 1784, demolished 1885.

'Lavendale', at the foot of Ushers Wynd, used as Free Church School, 1844–77.

The issue of roads came to the fore in 1770, the condition of the east and north routes having been described earlier and the turnpike road to Edinburgh was laid soon after. Two years later the Road Trustees then turned their attention to creating one between Peebles and Innerleithen, which required negotiating Dirt Pot Corner, so-called because of the dark deep pool in the meander of the Tweed there. It was to be built in the valley instead of following the elevated route through Glenormiston. A toll house was erected at Horsburgh Castle and estimates sought for a bridge over Leithen Water, which previously had to be crossed by a ford.

The slow progress of modernising Peebles was to accelerate in the middle of the 1800s with the arrival of railways and woollen mills, but at the start of the new century Peebles was fairly static both in size (it still essentially consisted of the original five streets) and population and summarised – albeit rather disparagingly – by Lord Cockburn in his quote, 'As quiet as the grave … or Peebles'. However, with a road to Edinburgh now in place, a journey to the city was easier and the modes of transport evolved from the ten-hour duration in William Wilson's two-wheeled wooden carriage pulled by one horse at the start of the century to the three-hour trip, and return the same day, offered by Crolls stagecoach by 1825. The High Street had been taken up in 1828 to lay gas pipes providing a reliable source of light and heat. The latter must have been particularly welcome as it was expensive to bring coal from Midlothian so peat was the main fuel available locally. In 1845, however, the entire length was lowered by 2 feet and at the same time pavements were made, drains put in, the road surface renewed and remaining thatched roofs taken away and slated. Untidy projections such as forestairs and the wells outside the Queensberry Lodging and in the Eastgate were removed, giving the thoroughfare a streamlined appearance; all this was made possible by a fundraising effort between the council and Peebleans.

Tweedside Mill was the first major commercial enterprise for Peebles and heralded a golden era for the burgh. The textile industry was not unknown in Peebles. A wauk mill had existed on Tweed Green since 1480, and there was a tradition of weaving that had begun a century later. Then production of cotton was tried in the eighteenth century and in 1829 a Galashiels manufacturer took over the old corn mill below Castlehill to make fashionable tartan material, which was apparently favoured by Walter Scott. However, Peebles had not been part of the flourishing woollen industry being enjoyed by other Borders towns like Hawick, Galashiels and Selkirk. The North British Railway line from Edinburgh opened in 1855, the train optimistically pulled by an engine named Tweed, and was the catalyst for Peebles' fortunes to change. No sooner had the smoke cleared when the corn mill premises were extended to accommodate Tweedside Mill in 1856. Mr Walter Thornburn & Bros took this over in 1875, having already built a second mill at Damdale in 1869. He was later to build a massive warehouse near the station, from where he distributed cloth to all parts of the world. A third mill, March Street Mills, belonging to D. Ballantyne & Co., opened in 1885 and during the intervening years, Caledonian Railway connected Peebles to Lanarkshire and Glasgow.

In the foreground is Walter Thorburn's warehouse, with Damdale Mill behind.

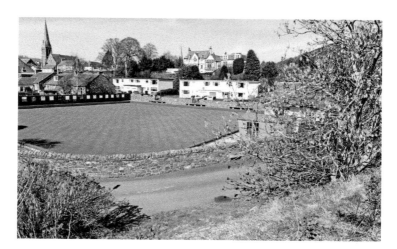

View from the embankment of Caledonian Railway link to Peebles East Station.

During these years, the town quickly learnt to capitalise on the needs of the burgeoning population and shops and trades filled every available premises. The first bank in Peebles, the British Linen Co., opened a branch in Glencorse House in Northgate (Sainsburys now occupies that site) in 1825. Prior to this, money had to be transported to Edinburgh by carriers.

DID YOU KNOW?
The British Linen Bank was the first to come to Peebles and set up a sub-branch at No. 68 Rosetta Road.

The other side of this expansive coin was a chronic shortage of accommodation, especially for the influx of mill employees. The burgh had not had any need to build new houses, so was ill-prepared for the sudden and large increase in its population. Consequently, cottages and houses were unacceptably overcrowded as lodgers were squeezed into already cramped conditions. Walter Thorburn utilised a mansion, called the Mount, across the river as a hostel for his mill employees from outside the area. By the late Victorian era, a certain number of villas had been built on the south side of the Tweed, but most housing was north of the Old Town where the council had been able to purchase ground at Kirklands. It is an interesting walk from Young Street – originally called Ludgate – at the top of Old Town, along Rosetta Road and March Street to see the chronological order of the cottages and houses built during this first extension of the town. The styles vary from block to block and each displays a dated stone or house name, as was the custom then. This period of development went as far as the poorhouse and included Wemyss Place, Gladstone Place, Crossland Crescent, Cross Street and Elcho Street, and Northgate was also extended as far as the railway bridge. In the early twentieth century, the council needed to build on larger scale municipal housing schemes such as Elliots Park, Dalatho and George Street. Meanwhile, the south side of the river was being developed too and it is worth quoting Robert Chambers, who, prior to the railways and mills, had talked of Peebles being a 'finished town', but who later said of developments 'a species of third town which promises to exceed the others in dimensions'.

It is sobering to reflect that the two factors instrumental to the prosperity of Peebles in the nineteenth and twentieth centuries have ceased to exist. The buildings and infrastructure of both railways, together with Tweedside and Damdale Mills, have all been cleared and the future of the March Street Mills, which only closed recently, is uncertain. The latter site encloses a large area of allotments, which were provided to employees in the past in lieu of a pay increase. These plots are enthusiastically worked by local people who are fearful of losing them to housing development.

The High Street of the twenty-first century is a rich tapestry of the burgh's history condensed into half a mile and is worth reviewing. A stone plaque above the fruit and vegetable shop marks the site of Mungo Park's surgery in 1801–02. Next door the medieval Deans House, altered across the centuries of inhabitants – the Hay family, William, Earl

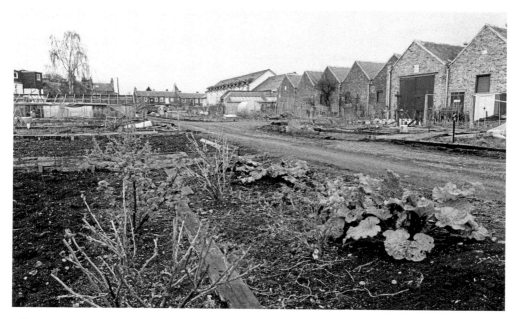

Allotments behind March Street Mills.

of March (Old Q), Dr John Reid – is now home to the John Buchan Museum. A lintel over the rear door is engraved with 'J.R. 1781'. An archway leads into the quadrangle of the Chambers Institution, generously gifted to the people of Peebles by the publisher William Chambers in 1859 to be used as library, gallery and museum, purposes for which it is still used. Modern history is represented too in this quiet space by the beautiful hexagonal-domed war memorial of 1922 enclosing a mosaic-embossed Celtic cross. On the other side of the pend from Newby Court is the 1753 Town House, but hidden behind is the Corn Exchange. It was not built until after the railway arrived, by which time the farmers had realised the convenience of sending their goods by rail to Edinburgh, so it had a very short lifespan. However, the bellcote above is thought to house the bell from the medieval tollbooth down Bridgegate. Farhills Close (could it be so-called because of the view to Newby Kips?) on the west side of the Town House is easy to miss but it contains a square marriage lintel from 1672 above a Georgian doorway. The Tontine Hotel of 1808 brought competition to the Cross Keys, which had, until then, the monopoly in Peebles, and the cobbled courtyard in front is the only one of its kind on the High Street. Every few yards, narrow closes squeeze between buildings and although some of them are gated, the open ones are worth investigation and may lead down to Tweed Green along the line of the ancient sloping gardens. A brass name plate 'W. Mitchell' is at the entrance to the workshop of this painter, whose office door is embellished with brightly coloured designs. Next to Rogersons shoe shop is a red gate juxtaposing a touch of 1930s art deco vintage with the fourteenth-century Parliament Square, where there is a marriage lintel with the inscription 'RS HM 1743' – such a long breadth of time in such a short distance. The ornate Victorian building with latticed windows is

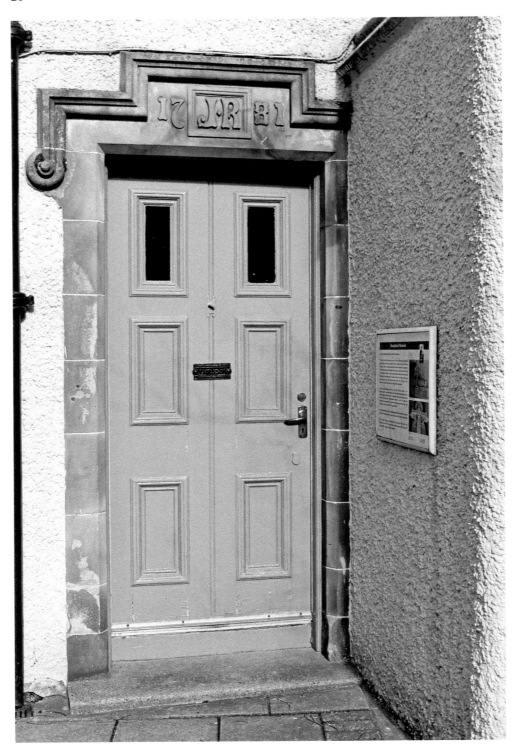

Initials of Dr John Reid in back doorway of Queensberry Lodgings.

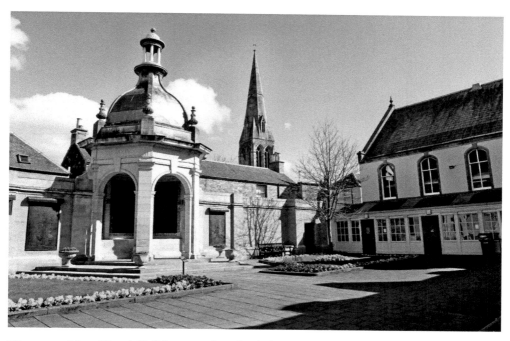

War memorial and Burgh Hall from quadrangle of Chambers Institution.

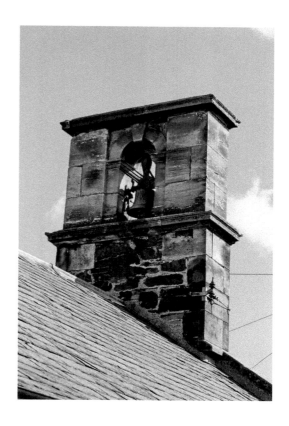

Bellcote of 1860 Corn Exchange.

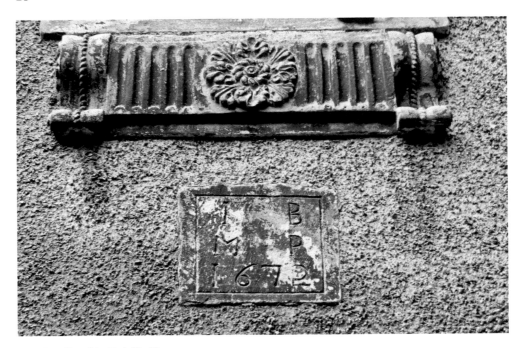

Marriage lintel in Farhills Close.

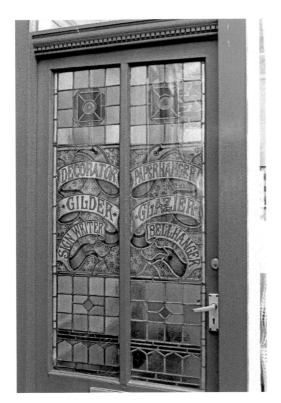

Office door of Mitchell the painters.

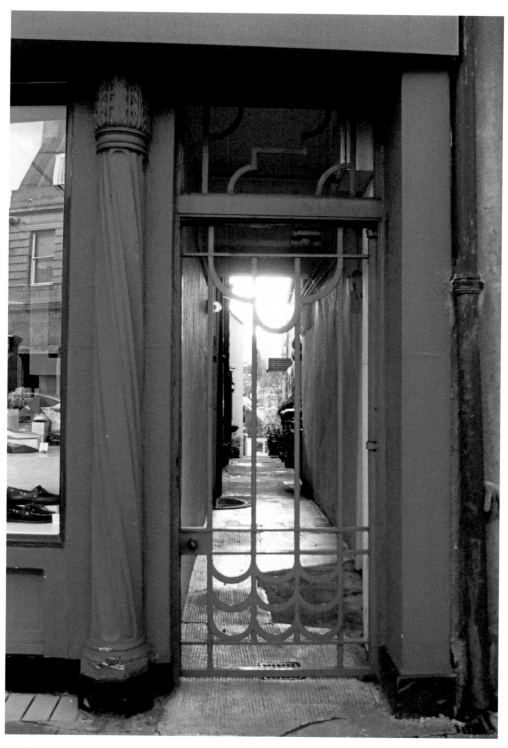

Art deco gateway next to Rogerson's shoe shop.

now Coltman's bistro but was erected in 1886 as the Caledonian Railway Hotel, which operated until 1930. On the front wall is a carved bull's head, the emblem of Turnbulls who built it. Mr William J. Whitie took over the well-known family bookshop in 1899, which utilised the room on the right-hand side of the hotel entrance, until purchasing the whole building when the hotel ceased trading. Whities Bookshop is a much-loved Peebles business, although the shop is now in Pennels Vennel. Across the road, the corner building is only half of what was known as Bank House, more famous now for its red door, a keepsake from the Buchan's legal business and family home. Walter Buchan was a solicitor, procurator fiscal and town clerk for almost fifty years and wrote *A History of Peeblesshire* in three volumes. His sister, Anna (pseudonym O. Douglas), edited these books and wrote novels of her own, reputedly in the top floor of the Italianate tower. However, these publications were somewhat overshadowed by the prolific literary output of their brother, John Buchan, 1st Baron Tweedsmuir, who wrote twenty-nine novels, forty-two non-fiction, ten biographies and four poetry books. The town is very proud of its association with this remarkable family, and not unsurprisingly reacted strongly when the proposal to widen Cuddy Bridge involved demolishing their home. The compromise was the building seen today but the issue aroused much local opposition, precipitating the formation of the Civic Society in Peebles. Half way down the narrow close at No. 82, a marriage stone above the door is inscribed 1648; in the gloomy light of the vennel away from the busy street, it is easy to transport the mind back a few centuries. The granite art deco façade of the Bank of Scotland from 1934 replaced the original classic building, from which the balustrades were saved and added to a house in Montgomery Place. It is worth

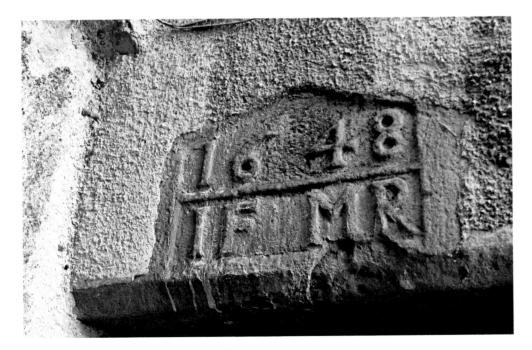

Marriage stone in the close at No. 82 High Street.

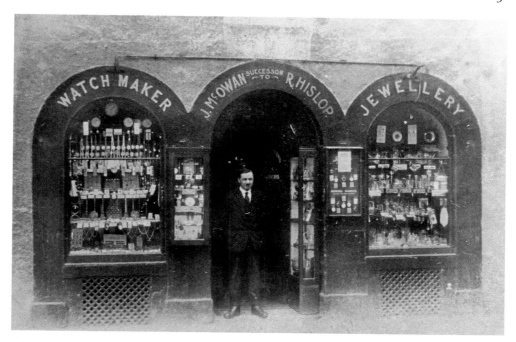

John McOwan, jewellers.

remembering as you pass Walters the jewellers that this was briefly used as a tollbooth in the eighteenth century, although the grids above the underground vaults have been removed. However, the premises has been a jewellery shop since 1863 when Robert Hislop transferred his clock and watchmaking business there from Bridgegate. It was then sold to a trained watchmaker from Crieff, Mr John McOwan, a familiar name to Peebleans and visitors alike as the business was continued by his sons John and Kenneth until 1990. The proprietor of this shop is responsible for winding the parish church clock three times a week. Most of the shop frontages are modern but the irregular roofscape along this side reveals some of the past history ranging from the flat-roofed 1930s Playhouse Cinema, through mock Tudor to the turreted Victorian baronial landmark of Veitchs (now Costa), which was built in 1886 for the family clothing business previously run from their home in Gladstone Place. In between, a two-storey house dates back to the eighteenth century when it belonged to Turnbulls the bakers; a square stone inscribed with the guild symbols of swaffles and shovels above the words 'God provides a rich inheritance 1724' is easily visible. The steep incline of the roof indicates that it was previously thatched. The baking tradition carries on at the back of the building where the old bakehouse – complete with original ovens – is a café called the Oven Door.

The High Street cannot be left without a mention of the Market Cross dividing the traffic at the junction with Northgate. The fifteenth-century shaft has done a bit of travelling over the centuries, although it was near its present location until 1807 when, in a decayed state, the council decided replace it. Sir John Hay realised the historic importance of the cross and offered to caretake the head and shaft at his residence of

Kingsmeadows House, where it safely remained until Chambers Institution opened in 1858 and returned to the public domain in the quadrangle there. In 1895 Colonel William Thorburn offered to pay for a new plinth so that it could be returned to the original location where it rested for seventy years until it became obstructive to the flow of motorised vehicles and the road was realigned; the cross moved a few meters and was reset on a new, lower plinth. The four carved panels from 1895 are integrated in a small memorial garden in Northgate.

Roofscape of Peebles High Street.

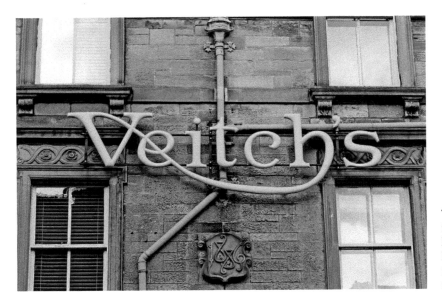

The Veitch family logo is a landmark in the High Street.

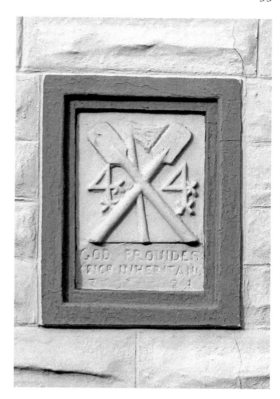

Trade stone of Turnbull the bakers.

Oven Door café inside the bakehouse of Turnbulls.

Private Houses

The Borders, because of its geographical position, is festooned with castles and tower houses, mostly built between the thirteenth and sixteenth centuries, and estimated to number 270 by the time of the Union of the Crowns in 1603, to defend the region from incursions by England. Peebles Castle predates this era and existed in the early 1100s when David I reigned; he used it as his royal residence when partaking of the excellent local hunting grounds, and probably also for administration connected to trade. The annual grant given from it to the Chapel of Virgin Mary nearby is not mentioned after 1327, and the castle is thought to have been destroyed during the First War of Independence. When the sheriff court was being constructed in 1841, remnants of the foundations, together with some medieval pottery, were found.

Neidpath Castle

Neidpath Castle, a large tower house, was undoubtedly built for defence in the late 1300s, standing in such a commanding location on the steep slope of the gorge above the Tweed. A lesser peel tower had been erected in the twelfth century by Sir Gilbert Fraser, who also had Fruid and Oliver Castles in the upper Tweed Valley near Tweedsmuir. His son, Sir Simon Fraser, heroically led the Scots army from Biggar to the Battle of Roslin in 1303 and defeated the English, but unfortunately was hung in 1307, along with William Wallace. The thinner walls of this first castle were the parts that were damaged by Oliver Cromwell's attack in 1650, and the evidence is there to be seen today. The present-day L-plan stronghold, with 11-foot-thick walls, was due to the Hay family, at that time Sir William de Haya, who was Sheriff of Peebles. Royalty, including Mary Queen of Scots and James VI, often visited, favouring the location for hunting. John Hay, 8th Lord Yester, was given the title 'Earl of Tweeddale' in 1646. His son, who was a leading statesman in the reign of Charles II, inherited the castle in 1654 and had considerable alterations done to the building. The original entrance was in the south wall overlooking the river and deer park, but a new door was made (through 11 feet of stone) on the east side and an enclosing wall erected above the gateway, of which is the barely discernible crest of Lords Yester, Earls of Tweeddale – a goat's head and a coronet. He also created beautiful terraced gardens on the slopes below, which were renowned in Peeblesshire and planted an avenue of yew trees along the entrance drive in 1654. They are recognised as a unique botanical variety named Taxus baccata Neidpathensis and are still there. The son who inherited this prosperous estate, another John Hay, Lords Yester, had a penchant for spending beyond his means, and after buying a great deal of land, accumulated serious debts, such that he had to sell Neidpath Castle in 1686. The buyer was William Douglas, 1st Duke of Queensberry, and the properties were to be renamed March Estates.

Neidpath Castle from the old deer park.

DID YOU KNOW?

Oliver Cromwell's army marched into Peebles in 1651 and captured Neidpath Castle. They set up a garrison in Hay Lodge Park, known at that time as Arnotshaugh, and stabled their horses in St Andrew's Kirk. The parkland was also used as a campsite by Charles Edward Stuart in 1745.

The Earls of March only stayed at Neidpath during the summer months and moved back to Queensberry Lodging in Peebles for the winter, but nonetheless made great improvements to the building and the grounds. Lord William Douglas, son of the 1st Duke and created a peer with the title 1st Earl of March (who brought the Hay family back into the equation through marriage), began planting ornamental trees and shrubs, work that was continued by his son into the eighteenth century and was to be the zenith for Neidpath Castle. He was also responsible for wider improvements to benefit the local community,

Avenue of yews lining entrance to Neidpath Castle.

including making a public road along the line of the current one rather than veering off sharply to the right through Jeddefield. This bend was at the entrance gate to the castle and known as White Yett. He also built old Manor Bridge in 1702, albeit using funds from the vacant stipend at Kirkton Manor Church. These first two generations of Earls of March were well liked in Peebles but the third one, William Douglas, born in Queensberry Lodging in 1725, was to herald the demise of the old castle. He showed very little interest in Neidpath, preferring to spend his time in London, living a debauched and indulgent life. When he was fifty-two, due to the death of the cousin in line for inheriting the dukedom, he was made 4th Duke of Queensberry and given the nickname 'Old Q'. His notoriety was compounded when he wilfully vandalised the beautiful woods around Neidpath and sold the timber. The devastation was even documented by Wordsworth in a sonnet:

> Degenerate Douglas! Oh, the unworthy Lord!
> Whom mere despite of heart could so far please,
> And love of havoc (for with such disease
> Fame taxes him), that he could send forth word
> To level with the dust a noble horde,
> A brotherhood of venerable trees;
> Leaving an ancient dome, and towers like these,
> Beggared and outraged! – Many hearts deplore

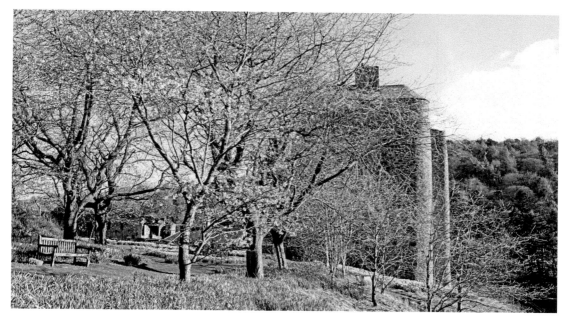

Cheery blossom at Neidpath.

> The fate of these old trees; and oft with pain
> The traveller, at this day, will stop and gaze
> On wrongs, which Nature scarcely seems to heed:
> For sheltered places, bosoms, rocks and bays,
> And the pure mountains, and the gentle Tweed,
> And the green silent pastures yet remain.'

He died in 1810, unmarried, and the castle became property of the Earls of Wemyss and March. It has been uninhabited since around 1731 but has been open to the public periodically, and used for films (e.g. *Braveheart*) and as a venue for weddings or other special occasions. A few exotic trees pepper the slopes near the castle and the approach is lined on one side by the old yew trees, but a vivid imagination is required to visualise the magnificent garden of old.

Black Barony

The Barony Castle Hotel is the current name of this grand house, which has undergone several changes of use and titles since it began life as a sixteenth-century tower house (known as Darnhall) belonging to the Murrays, Lords Elibank. There are tales to be told about the history but none more unusual than the recent story of the Great Polish Map of Scotland, which can be seen in the grounds. During the Second World War a group of 1st Polish Armoured Division were stationed in Galashiels. Their sergeant, Jan Tomasik, was treated for injuries in Peel Hospital, and later married one of the nurses who cared for him. He had a successful hotel business in Edinburgh but in 1968 purchased the Black Barony

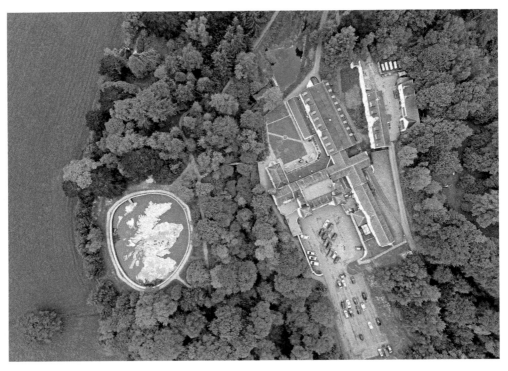

Great Polish Map of Scotland. (Photograph by Robbie Macdonald, 'Mapa Scotland SCIO')

Avenue of lime trees along the original entrance to Black Barony.

and the extensive grounds, which had been landscaped in the mid-1850s but were ripe for improvement. His debt of gratitude to the hospitality of the Scottish people inspired him to create a relief map of Scotland, which was made during the summers of 1974–79 by students from Krakow University; the template was taken from a copy of Bartholemews Atlas, which was discovered in one of the rooms in 2003. The concrete core is enclosed by a circular wall containing water that flows through the river system. The unique feature was neglected after Jan died and the hotel changed hands and the overgrown map became unrecognisable until a group of enthusiastic volunteers formed MAPA in 2010. They have restored this unique folly to its former glory and erected a viewing platform from which it can be appreciated.

The grounds are no stranger to ornamentations. In 1843 the 9th Lord Elibank, Alexander Oliphant Murray, repaired and altered the decaying house and landscaped the grounds, embellishing them with fashionable Victorian structures including a gazebo, summer house, an iron bridge across the ravine of the Fairy Dean and the Bellview Temple. The origin of this name came from 1507 when Sir John Murray gifted a bell to the parish. It is from Holland and inscribed with three medallions – the Virgin and Child, St John the Baptist, and an owl below a scroll – and bears the date 1507. It was housed in a tower on the edge of the village, an area appropriately known as Bellfield, until being put into the parish church of 1829. By the twentieth century, most of these man-made features have decayed or been vandalised, but the eighteenth-century avenue of lime trees still is intact, but not used as the grand entrance to the house now.

Winkston

This tower house is somewhat obscured from view by the elegant nineteenth-century farmhouse that succeeded it.

DID YOU KNOW?

There is only one documented assassination of a provost of the burgh of Peebles. He was John Dickson of Winkston, killed in 1592, and no one was ever charged for the crime. The ancient office of provost ceased in 1974.

The original was built in 1545 for Peebles provost John Dickson and was a three-storey oblong structure with 1.3-metre-thick walls. It is the first known house to incorporate gunloops (also called shot holes) at a time when hand firearms came into use and the threat of attack was not from armies any more but from small groups of raiders. When erected there was likely to have been a vaulted cellar, ground-level hall and chambers above, accessed by a stone stair (the original entrance and stairway plans were lost) and the lintel above that first entrance was placed above the present doorway. The inscription is 'ANNO DOM 1546'. In 1743 the house was upgraded to become one suitable for a laird; the vault and stairs were removed and a central staircase was put in and dividing walls were added to create rooms. Also, the top storey was taken away, chimney stacks built

at both ends and windows made. A large fireplace with wooden surround almost fills one wall of the downstairs parlour, while both second-floor rooms also still have their fireplaces, all of them from this period. The tenants are thought to have been John Little and his wife from Foulage, which fits in with the lintel above a window, inscribed 'IL 1734'. The property changed hands several times thereafter but from 1850 it ceased to be used as a dwelling – most windows were blocked up and has since been utilised as a farm store.

In 1755, when geology was in its infancy and the line of the Midlothian coal seam was not understood, William Malcolm applied to the Burgh Council for a grant to dig for the fossil fuel at Windylawsburnfoot, near Winkston. Needless to say the excavation proved fruitless.

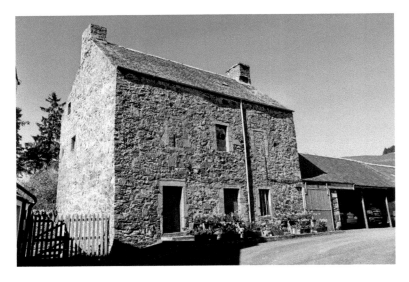

Winkston Tower.

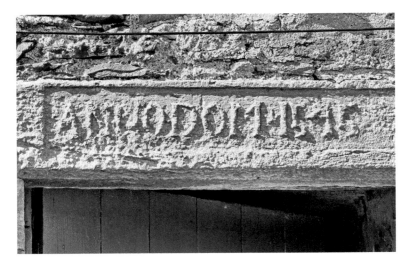

'ANNO DOM 1546', Winkston.

Hay Lodge

In 1635, Andrew Hay bought the lands of Henderstoun, which included some the old royal demesne of Glensax, and changed the name to Haystoun. The Hays were already landowners living in Smithfield Castle, where Venlaw House now stands. During the eighteenth century, John Hay of Haystoun had two sons, the eldest of which, Dr James Hay, inherited the estate. His brother, Adam, who worked as an Edinburgh merchant but gave up commercial life for the army, wanted to keep up with his sibling by becoming a country gentleman too. He first bought ground in Soonhope and then had the villa of Hay Lodge built in the early 1770s on land feued by the Burgh Council. Initially he appeared successful, being appointed sheriff-depute for Peebles and spending a short time in Parliament, standing in for James Montgomery of Stanhope in 1767. However, he had stretched himself too far, and by 1775 was in serious financial difficulty and died suddenly soon after, having only lived in Hay Lodge for a few years. Soonhope was then sold to his brother James.

The house itself sits on top of a slope above the Tweed near Ministers Pool. Across the road is a stable block with a pigeon loft above, the original building being L-shaped and covering the site where the modern Hay Lodge Cottages now are. The icehouse is still visible in the park, as is the eastern wall that once enclosed a vegetable garden. Walking down Hays Vennel, it is worth noting the original eighteenth-century keystone archway, which would have led into the courtyard of Hay Lodge. In the north-eastern corner of the wall is a blocked-up arched window, marked on Wood's 1823 map as a small building, which is thought to have been a pump house or well. The enclosure is inaccessible now, having been fenced off by Scottish Power!

The area of Hay Lodge Park, much loved in the present day, used to be called Arnotshaugh and belonged to the Chapel of St Mary. After the Reformation, it became burgh property but the council divided the land into eight lots and, together with part of adjoining Kirklands and as they were so hard up, realised they could get some funds by selling it to a variety of individuals. William Douglas, 2nd Earl of March (who planted the gardens at Neidpath Castle) wished to extend the policies of the castle, so purchased these plots, creating what was known as the North Parks of Neidpath, only for the family to sell them again in 1797. After a succession of owners, they were bought in 1822 by Glasgow merchant Alexander Campbell, who was responsible for building the wall along the northern edge of the park, affectionately known to this day as Campbells Dyke. His father, Mungo Campbell, owned Hundleshope, which was inherited by his other son, the wonderfully named Robert Nutter Campbell, already proprietor of Kailzie and Nether Horsburgh, and whose portrait (with his wife) was painted by Henry Raeburn and hangs in Kelvingrove Gallery. The story has a happy ending because, in 1919, the council repurchased the parkland, together with the haugh on the south side of the river as far as Neidpath Viaduct, resulting in the beautiful public amenity that so many people enjoy. Hay Lodge House is now used by the maternity staff of the Borders Health Board, the old B-listed building juxtaposed with the modernity of the cottage hospital and health centre, opened in 1983.

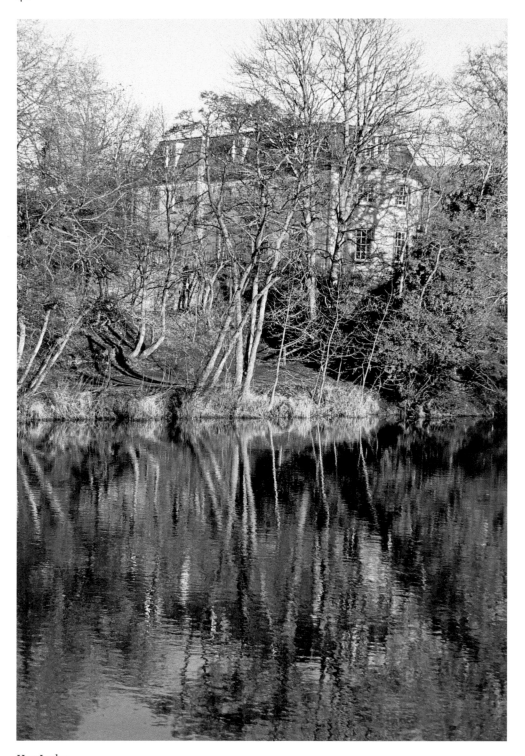

Hay Lodge.

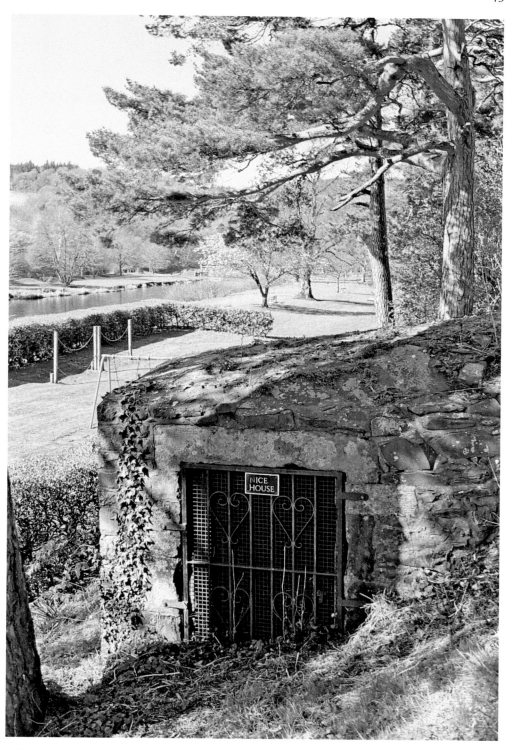

Icehouse of Hay Lodge.

Keystone window in the wall of Hay Lodge.

Kingsmeadows House

In the sixteenth century, the Hays of Smithfield owned the adjoining eastern lands of Soonhope, Eshiels and Glentress and in 1570 bought the King's Meadows. By 1683, the family fortunes had reversed and, burdened by immense debt, this branch of the Hays lost the Smithfield estate, never regaining it. However, the Hay family were nonetheless major landowners on the south side of the river, possessing Whitehaugh, Haystoun, Newbie, Glensax, Bonnington, Crookston, some of Cademuir, King's Muir, Bridgelands and Hundleshope, and in 1660 built the mansion house at Haystoun as their country seat. The wild, bare moorland began to be 'tamed' in the late 1700s by Dr James Hay, who, albeit resident in Edinburgh where he worked as a physician, ensured extensive agricultural improvements were carried out on his family estate. One of his sons, John (later Sir) Hay, built Kingsmeadows House in 1795, leaving his two spinster sisters, Miss Betty and Miss Ailie, known as the 'leddies of Haystoun', alone in the big house to get on with their flax spinning. At the eastern end of policies, a grotto was built, remains of which can still be seen, and the surrounding area planted with trees, now a mature woodland. A short distance further on, Sir John Hay had a wire bridge built across the river to the Innerleithen Road, purportedly to deter people from walking in front of his house, but this is apocryphal.

Sir John Hay and his wife, Elizabeth Forbes, had fifteen children and quickly outgrew the original mansion, so the west front was extended in 1811, with care being taken not to damage the Mercat Cross of which he had taken custody of a few years earlier. Further

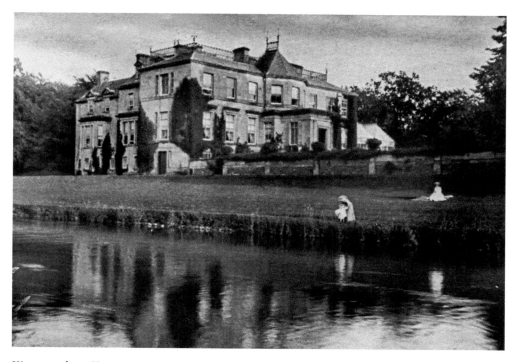

Kingsmeadows House, 1904.

Dolls House, Kingsmeadows.

additions followed in the middle of the nineteenth century including an orangery, bowls of fruit from which Lady Hay was prone to present at auspicious public occasions (it was demolished in 1960). Also, an ornate iron gate was inserted into the boundary wall opposite the stables through which a delightful little structure, known as the Dolls House, can been seen in direct view. The latter was built by the next owners, the Mitchells, who bought Kingsmeadows in 1920 and who, in contrast to their predecessors, only had one child and would spend time amusing herself in her own little home. Harry Nelson Mitchell was part of the Stephen Mitchell Tobacco Co., founders of the Mitchell Library. During the Second World War the house was used as an emergency maternity hospital, both for local residents and mothers from Glasgow, and the family moved into Whitehaugh Farm until peacetime. Post-war, Peebles was finding it difficult to find sufficient workers for the mills and, due to a shortage of housing, people were brought from Midlothian by bus to bolster the workforces. The council took the decision to compulsorily purchase some of Kingsmeadows policies to build a municipal housing scheme, shortly after which Kingsmeadows House was sold. The buyers were Standard Life, who used it as a repository for their records, considering it a safe haven in the case of a nuclear attack. In 1999, to celebrate their 175th anniversary, the company refurbished the property and offered their staff holiday accommodation there. In 2013, it was once again on the market and after an unsuccessful attempt for a community buyout, it was sold to Granton Homes, who have converted the house into elegant luxury apartments.

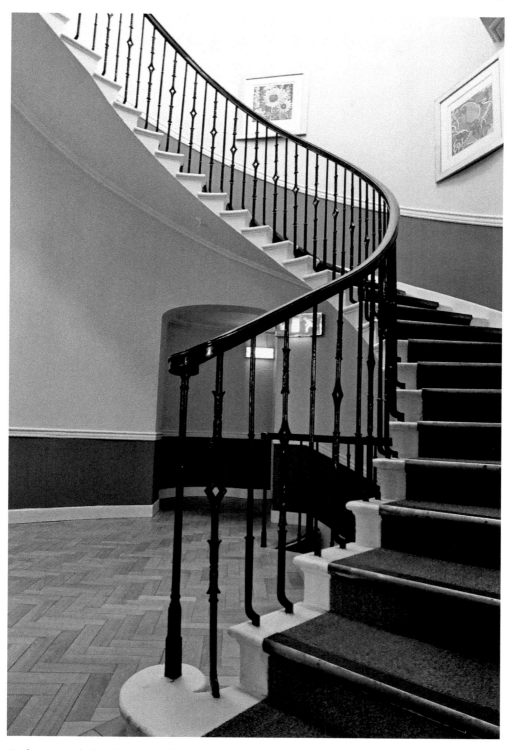

Oval entrance hall and stairway, Kingsmeadows House.

48

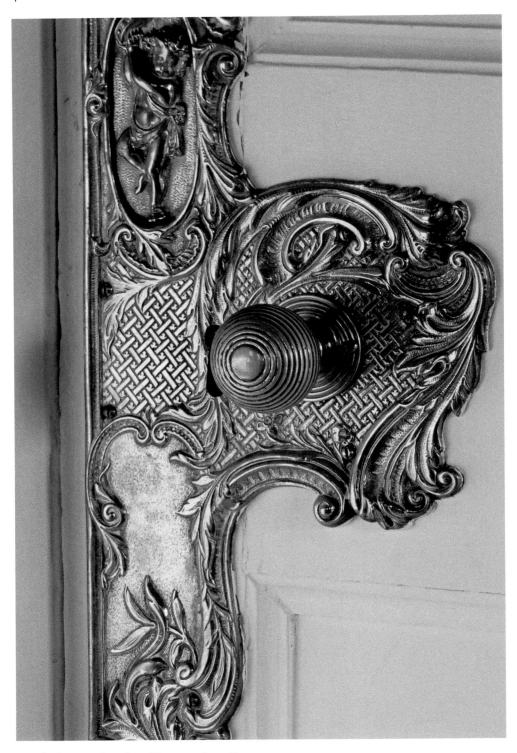

Detail of rococo doorplate, Kingsmeadows House.

Biggiesknowe

The majority of Peebles residents lived simple lives in small houses or cottages. The lifestyle can be illustrated by the example of the Chambers family, later to become so well known in the town and further afield. William Chambers came to Peebles from Glasgow where he had trained as a cotton manufacturer, and began a handloom weaving business in Biggiesknowe, which was very successful, and at its height, 100 looms were busy in a workshop at the top of Old Town. He built a cottage next door for his son, James, who continued the business after William died in 1799, although he did not possess the same enterprising spirit as his father. Two of his children, William and Robert, were to become well-known publishers and authors, but their beginnings were humble; the living accommodation was pokey, compromised by the box beds jutting into the limited space heated by the peat fire, as coal was expensive to transport from Midlothian. Schools charged fees for children's education, the subjects of which were very restricted, (although always involved Bible study), and the pupils were subject to harsh discipline with frequent resort to the tawse, and taught in overcrowded schoolrooms. Despite these hardships (or perhaps because of it) the community spirit was strong, neighbours helped each other in times of difficulty, and the quiet town was content with the rural way of life. Both of Chambers' sons had an appetite for learning, but had very little opportunity to read books until 1791 when Alexander Elder opened a small bookshop in the High Street, selling quill pens, paper and a few publications, as well as starting a circulating library. The shop was typical of the era, having the domestic cow kept at the back when it wasn't on the common grazing land. When William was eleven years old, his father was tempted to buy from Mr Elder a copy of *Encyclopaedia Britannica*, an extravagance he could ill-afford, and after the first flush of enthusiasm faded, the volume was put into the attic because it took up too much space in the living room. To William, the cramped loft became an Aladdin's cave where, for a whole year, he voraciously consumed knowledge beyond his wildest imagination until the precious book had to be sold to pay off debts accrued in the family business. This coincided with a downturn in an already struggling business when mechanical looms were replacing hand-operated ones, and the situation culminated in his father trying to make ends meet by opening a drapery shop, a trade in which he was inexperienced, and ultimately failed. Bankruptcy was hastened by unpaid debts from the Napoleonic prisoners of war to whom the trusting and kindly James Chambers had extended credit for his goods, and the family were obliged to leave Peebles for Edinburgh. After William's horizons had been widened by the *Encyclopaedia Britannica*, he knew his heart lay with books and managed to procure a position as apprentice in Sutherland's bookshop in Calton Street, where he was forbidden to read while at work but was allowed to take books home in the evening. He lived in digs in the Grassmarket and quickly learnt about the importance of self-reliance by living frugally, earning very little but working very hard, the grounding which stood him in good stead for self-employment. He frequented book auctions and 'trade sales', and at one of the latter met a London trader who was to prove instrumental in changing William's life. The agent, to whom William had offered assistance in packing and stacking books, gave him £10 of stock on credit, which he was able to sell from trestles on the pavement outside his rooms on Leith Walk. Slowly, he developed a modest income; first he started binding

book sheets himself, then learnt calligraphy with which he transcribed poems and finally he bought a second-hand printing press, along the way becoming acquainted with literary figures, including Walter Scott. Robert was a natural-born writer, producing *Traditions of Edinburgh* in 1824, and together they printed and edited pamphlets and periodicals, the most successful being *Chambers's Edinburgh Journal*, which started in 1832. W&R Chambers was then founded and from it came the innovative *Chambers Encyclopaedia*, compiled between 1859 and 1868. Their achievements were remarkable, and some of William Chambers' financial success was shared with his birthplace by the gift of the Chambers Institution in 1859 providing a library, reading room, museum and gallery for the 'social, moral and intellectual improvement' of the people of Peebles. In 1910, Andrew Carnegie donated £10,000 for improvements to the building, on condition that the lending library became free. The house where their lives began in Biggiesknowe bears a memorial plaque.

The clusters of cabins at Eddleston and Soonhope Glen, although not residential, are noteworthy to conclude this chapter. They are all individual, colourful and quirky but were built by miners from Rosewell as retreats from the urban grime and a place where they could reconnect with nature.

Chalets in Soonhope Glen.

Religion

Ecclesiastical buildings dominate the approaches to Peebles. The main road from the east passes three churches as it reaches Eastgate, which leads into the High Street, the end vista of which is filled by the imposing frontage of the crown-spired parish church sitting on the hillock that once housed Peebles Castle. In the fourteenth century there was the religious establishment of the Chapel of Virgin Mary, endowed in 1367, which was situated across this junction as we now see it and whose presence has long since been obliterated by modern Peebles. The road to the left over Tweed Bridge sweeps round to run parallel to the river, opening a panorama across Tweed Green, graced at one end by the elegant Andrew Leckie Church and its 146-feet-tall spire. Alternatively, a right turn at the foot of High Street across Cuddy Bridge leads up through Old Town to the remains of twelfth-century St Andrew's Church and the prominent restored tower.

Less obvious is the sanctuary in which lie the remains of the Cross Kirk, encircled by mature Scots pines. It was here that relics of a cross, together with a stone urn containing ashes and human bones and inscribed with the words 'The place of St. Nicholas the Bishop', were discovered in 1260. The truth about the connection to the saint has never been ascertained, but in the thirteenth century the find was so significant that the

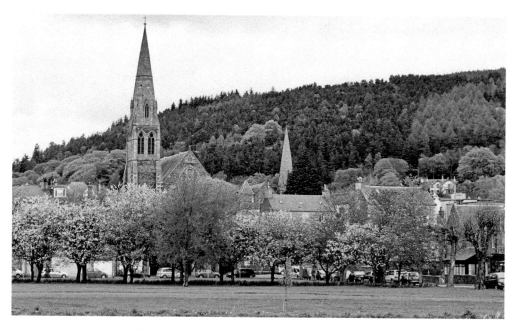

St Andrew's Leckie Church.

then king, Alexander III, ordered the founding of Cross Kirk, whose shrine became the destination for pilgrims. It was looked after by a small number of Trinitarian monks, or Red Friars. Over the next 200 years the community grew and in 1473 a full monastery was erected there, including the tower seen today. A tree-lined track led northwards from here to a chapel sited on a knoll at Chapelhill Farm; it was demolished in the sixteenth century in favour of a tower house, where the valuables from the Cross Kirk were secreted in 1564, but they have never been found.

The Reformation in 1560 changed the status quo. St Andrew's Church had been badly damaged by the English army in 1549 and was no longer suitable as the parish church, so the congregation moved to Cross Kirk. Both bells were transferred from the damaged church, one taken to the tollbooth, the other to Cross Kirk. The friars gradually dispersed, and their domestic quarters were used in 1605 and 1666 for victims of the plague. By 1778, the cost of continual repairs became prohibitive and a decision was taken to build a new church at the foot of the High Street on the motte site of Peebles Castle. One of the conditions stipulated was that the bell and clock from the Steeple (a defensive tower) be transferred to the new kirk. The Cross Kirk was literally abandoned and only seen as a source of reusable stone by masons; one such, John Hislop, agreed a price for the materials, but met with local opposition when a petition was raised by the minister, Revd Dalgleish. An agreement was reached and the ruins remained standing. However, there was another close shave in 1808 when an application was made to use the ground as a coal depot. Later that century, Dr Clement Gunn, who was particularly interested in the Cross Kirk and was vexed how neglected the church and surrounding area became, reported that one of the walls was used to support a henhouse. He strove tirelessly to have the sacred precincts tidied up and restored and after his death, a plaque was unveiled in 1935 in appreciation of his work. The Cross Kirk is now under the care of Historic Environment Scotland. There is a private graveyard belonging to the Hays of Haystoune, discretely tucked away in the southern corner of the grounds.

The oldest building in Peebles is the former parish church of St Andrew's, dating from the twelfth century, although only fragments of the original north wall remain, and they are overgrown with ivy. The church was made into a collegiate foundation in 1542, but only six years later was burnt by the English. Ironically, in 1651, Oliver Cromwell's troops, having captured Neidpath Castle, used the vacant church to stable their horses. The original tower was flat roofed and the attractive building of today is the result of major restoration funded by William Chambers in 1883. Inside the building, gravediggers' shovels lie abandoned. The churchyard, however, has stories to tell. The aforementioned Revd Dalgleish, who was highly respected and served the royal burgh for forty-seven years, fell foul of the town council for allowing his cows and horse to graze in the cemetery (only sheep were allowed to keep the grass short), and a lock was duly put on the gate.

Peebles and the remote parishes of the county were not immune from visiting Resurrectionists in the 1820s. Hare (Burke's partner in crime) was familiar with the area, having been employed as a labourer in Manor Valley and a farmhand at Nether Horsburgh. It was a frightening and unsettling period for the residents of Peebles, who became wary of strangers attending funerals or asking directions to the manse. Local men volunteered to take turns at watching the churchyards at night for body-snatching attempts.

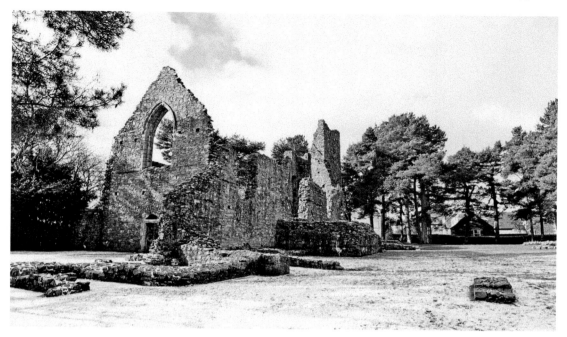

Cross Kirk.

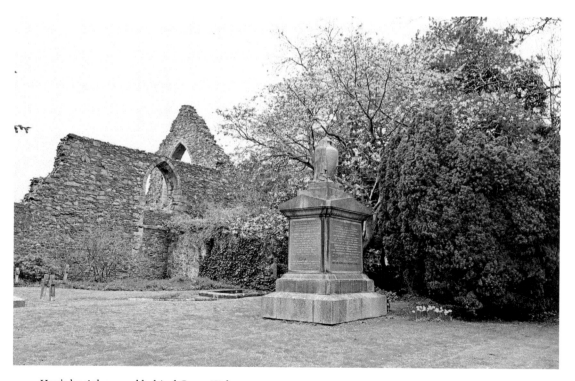

Hay's burial ground behind Cross Kirk.

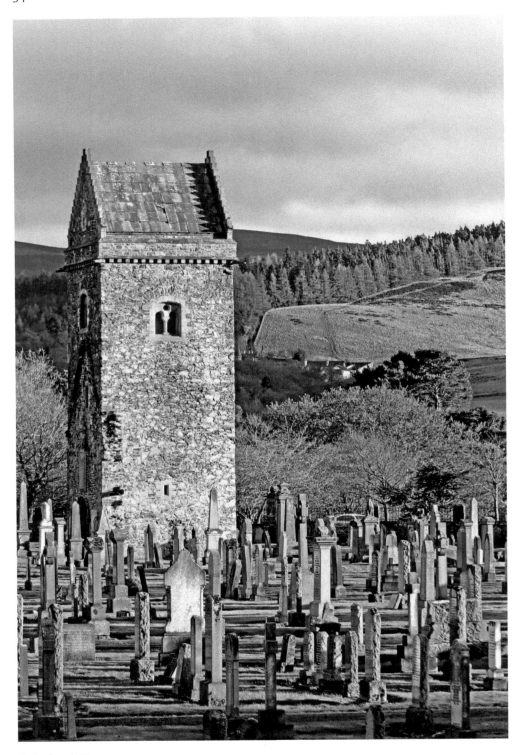

St Andrew's Tower.

Interior of the tower.

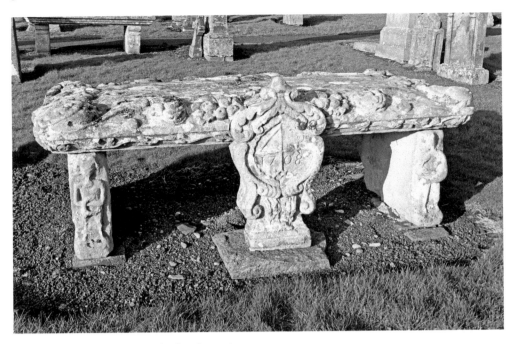

Table tombstone of the Tweedie family, 1708.

The churchyard of twelfth-century century St Andrew's has been used for over 800 years and in consequence has an interesting and rich array of gravestones. Most notable are the artistic table tombs of early eighteenth-century origins, particularly those of Thomas Hope, which has life-size figures of a man and woman lying side by side along the slab, with the ornately carved one dedicated to the Tweedie family. In 1967 a tombstone, thought to be early Christian, was discovered in the wall of the public garden in Old Town. Known as the Neitan Stone, it is displayed at Tweeddale Museum. An area known as the Strangers Nook is devoted to military officers and French, Italian and Polish prisoners of war who were in Peebles in the early 1800s after the Napoleonic Wars.

The manse for the parish church minister was at the top of Old Town just before Hay Lodge and is marked on early maps as Personnes Manse and thought to date back to the early 1600s. In 1813, when Reverend Buchanan began his tenure, the Kirk Session contemplated pulling it down and rebuilding, but they settled for repairs only. Dr Gunn had lodgings here when he first arrived to set up his medical practice. In 1888 a grand three-storey manse was built along Innerleithen Road, which is now privately owned. The old one, whose name is Lee Lodge on the 1906 map (named after Dr John Lee, minister of the parish church, then Professor of History and Divinity at the University of St Andrews in 1812), became the Riverside Hotel but was eventually pulled down in 1986 and the sheltered housing complex Riverside was built.

The layout of medieval Peebles is now difficult to visualise but there was another significant ecclesiastical building, the Chapel of the Virgin Mary, founded in 1367, and associated with Peebles Castle, which was located across the western end of the modern

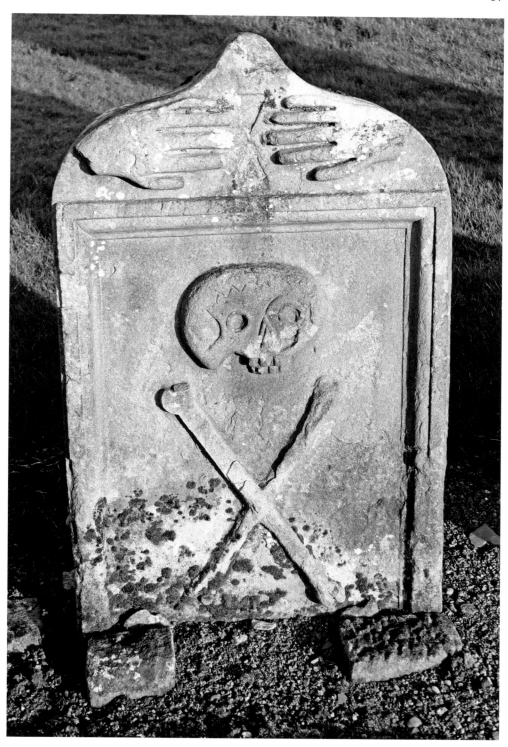

An unusual gravestone.

High Street. It became burgh property after 1621 and used variously as a meeting place for the town council, a place for daily sermons – at the request of locals who thought it more convenient than Cross Kirk – and even as a makeshift prison. The steeple bell was a familiar sound, being rung to call the council or to remind the residents to go to pay their taxes three times a week. By the end of the eighteenth century, the building had been cleared and all traces of this structure have disappeared under the modern busy High Street.

After the Reformation, there was a gradual increase in the power that the church exerted over people's everyday lives as it attempted to impose strict religious values and suppress superstition, which included persecution of witches, who were punished by burning or strangulation. Worshippers were not only expected to attend every church service, but be loyal to their own parish church; miscreants who were reported for appearing at a neighbouring parish service were called before a committee of the presbytery to explain themselves. Equally, the congregation was encouraged to maintain a critical eye on the minister, his sermons and behaviour. Punishment for these 'crimes' was often meted out by humiliating practices such as standing barefoot outside the kirk door, dressed in sackcloth, or chained to the wall in a neck iron for a matter of days, in full view of the rest of the community. There was also the notorious stool of repentance as well as fines and fasting days used as deterrents. During the next few decades, the kirk became increasingly paranoid as these measures seemed ineffective and tried to influence their flock by enforcing the practice of 'adherence to the Sabbath', whereby the community was not permitted to undertake any work or outdoor pastimes, even walking (apart from the journey to church), making them prisoners in their own homes for the day. It was also frowned upon to chat or gossip to each other after the services, which was particularly harsh for the rural communities who did not see their neighbours from one week to the next. To our modern sensibilities this oppression seems unthinkable.

DID YOU KNOW?

The spire of the first parish church, built in 1778, was 7 feet higher than planned and had the wrong taper. The building was unpopular with Peebleans and was replaced by the attractive crown-spired one that now punctuates the west end of the High Street.

A major controversy arose in 1873 regarding the ringing of church bells, an issue which ultimately was referred to the House of Lords! There were three bells in the steeple, one was rung for services, one for funerals and the third (rescued from the demolished prison) for summoning people to work. However, at the time the parish church was built, there were no other denominations with sacred premises, but during the nineteenth century that situation changed, although none of the new churches had bell towers. The Free Church, established in 1843, wrote to the *Peeblesshire Advertiser* in 1873 complaining that

their Sunday evening worshippers were not greeted with a peel of bells, despite the latter being the property of the burgh which, they argued, had a duty to all residents. However, the Lords upheld the case that the bells were exclusively for use of the established church. Since the Reformation, Catholics had only been able to attend mass in the small chapel at Traquair House, but in 1850 they began to worship in a room above the carpenter's workshop behind the Corn Exchange; a plaque acknowledging this can been seen on the house off Newby Court. Their own church, St Josephs, was built in Rosetta Road eight years later, complete with presbytery and school.

The current parish church replaced its predecessor with the bulging steeple in 1887. Once again, the clock was retained and a new bell was cast from two that had hung in the Cross Kirk. It weighs 15 cwt and is inscribed with the wording, 'This Bell, the property of the Burgh of Peebles, was recast in the year Eighteen hundred and eighty-six, from two Bells formerly in the tower of the Old Cross Church.' Dr Clement Gunn and his future wife were the first couple to have a Proclamation of Banns read at the opening Sunday service. Later in his life, he wrote several books about the churches of Peeblesshire.

The flat area behind the church on top of the knoll was an ancient bowling green, laid out around 1720 and used right up until 1874; at that elevation, it must have been a windy location! The Bowling Club, started in 1829 moved to Walkershaugh in 1874 and the modern church centre was erected on this land in 1982. The larger of the two halls is dedicated to Revd David MacFarlane, minister of this church from 1970 for twenty-seven years.

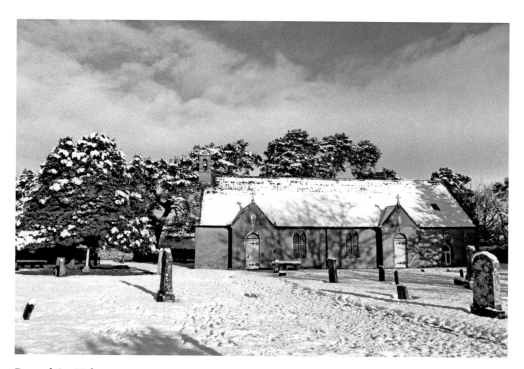

Drumelzier Kirk.

Inside the church are some visual treats. The oak pulpit is embellished with beautifully carved figures, animals, birds and fruit and is the work of Glasgow artist John Crawford. It was donated to the church in 1913. Another gift is the collection of twenty-two paintings done by Revd Roland Portchmouth; they are contemporary depictions of biblical themes and are hung throughout the building. The internal space is illuminated on all sides by the rich array of stained-glass windows creating a colourful ambience, particularly when the sun lights up the southern wall.

Some Peeblesshire parishes were suppressed in the 1600s, those of Hopkailzie (now Kailzie), Kirkbryde and Dawyck. The former church at Kirkburn became the property of Kelso Abbey in the twelfth century but was replaced by a new one in 1614, only being used for sixty years before the parish was annexed to Traquair, along the Kirkbryde. The burial enclosure has stones dating back to the eighteenth century and it is thought to be the resting place of the Williamson family of Cardrona. Nearby, a more recent memorial chapel, now converted to a dwelling, was created from two stone cottages and dedicated to William Cree, late of Kailzie, who originally paid for the restoration in 1921 to provide the community with a village hall. Apparently, a stone lintel with the words 'HOUSE OF PRAYER 1614' was incorporated into the fabric, having previously been used as a mantelpiece in the Old Horsburgh Tollhouse.

Dawyck parish was a chapelry of Stobo until the Reformation, but when suppressed in 1742, it was joined to Drumelzier. Sir John Naesmyth of Dawyck replaced the old church in 1837 with the private family chapel and mausoleum, which can be viewed from Dawyck Botanic Garden and Arboretum. Drumelzier, being the epicentre of the (notorious) Tweedie family of sixteenth- and seventeenth-century Upper Tweed, has their coat of arms above the door, although a replica has replaced the original, which was weather worn.

In the twenty-first century, although Peebles retains a healthy patronage of the mainstream churches, it is undeniable that the role of religion is much diminished as society becomes more secular. Most of the rural Peeblesshire churches are underused and St Andrew's at the foot of Old Town was demolished after the congregation merged with Leckie Memorial Church. A shining example of change-of-use, however, is that of the previous Free Church, which was converted into the Eastgate Theatre and Arts Centre, the only venue of its kind in the Borders.

Welfare and Medical Matters

The earliest records of establishments for care of the sick and frail pertain to St Leonards Hospital in the 1300s, which was associated with the Red Friars of Cross Kirk. It was at Chapelyards, part of Eshiels lands, sheltered under the hillock that is now crowned with the remains of Horsburgh Castle. Post-Reformation, it was abandoned and the land passed into the ownership of the Hays of Smithfield. The site was marked by an ancient tree until the nineteenth century but there is no trace now.

Throughout the fifteenth, sixteenth and early seventeenth centuries, the Borders folk must have lived in a state of fear, so frequent were incursions by the English, theft of their livestock by reivers, feuding between families and the threat of the plague. There was a small outbreak in Peebles in 1604–05 and again in 1645 and 1666 and the victims were isolated in the old domestic quarters of the convent at Cross Kirk, just outside the town. When there was an outbreak of pestilence elsewhere, particularly Edinburgh, a watch was kept to prevent strangers entering the town.

Site of St Leonard's Hospital below Horsburgh Castle.

The 1600s were particularly hard. As the century progressed, so did the amount of poverty. In 1741, after a very severe winter, crops failed and the council had to purchase meal to sell to the poor at cost price and people were asked to buy no more corn or meal from the market than they needed. Those who were disabled had to rely on charity, although the council were responsible for transporting them to other locations, a task they were pleased to carry out if it relieved the burden on the impoverished community. By the end of this century, the health of Peebles must have been dire. There was a succession of severe winters and poor crop yields, such that livestock died from cold and disease and farms had to be abandoned. Even poaching an occasional fish from the Tweed incurred a fine from the kirk. Trade was at a stand-still, the council's finances were in a parlous state and death and beggars were all around. It would take decades to climb back from this state of affairs.

Until the eighteenth century, the waterlogged low-lying ground in much of Peeblesshire was not suitable for growing green or root crops and consequently no winter feeding was produced for cows, so they were killed in autumn and the meat preserved by salting. The rough ground on the surrounding hills, Cademuir, Venlaw, Hamilton Hill and Glentress, was mostly common ground divided into soums – units of land sufficient to feed one cow or five sheep – which was rented to burgesses of the burgh. This practice was documented in the first council records of 1456 and continued for centuries, albeit fraught with feuds between the council and landowners over rights of pasturage. Agricultural improvement began in the early 1700s after the Union with England in 1707. Landowners gradually drained, fenced and enclosed their land and began crop rotation. Turnips, potatoes and various grasses were grown, widening the diet and improving the nutrition.

Blackie sheep on Cademuir Ridge.

The first medical doctor about whom there is some knowledge is Dr James Reid, who purchased Queensberry House in 1781 from William Douglas, 3rd Earl of March, later 4th Duke of Queensberry, but, thankfully, better known as 'Old Q'. He and his family resided there until 1857 when it was sold to William Chambers, the man responsible for the treasured cultural centre of the Chambers Institution. Dr Reid trained at Edinburgh Medical School alongside pioneering colleagues such as Dr Cullen and Dr Gregory during the Scottish Enlightenment and practiced as a physician and surgeon in Peebles for more than fifty years before he died in 1803. His reputation spread beyond Peebles so that patients travelled from further afield to consult him. It is alleged that he was called out at night to a shepherd at a remote sheiling and required to perform emergency surgery. The only source of light was a candle, which he duly wedged in a hole in his hat to illuminate the operation. Apparently the man's life was saved. He also played a prominent role in the burgh, being provost twice, a town councillor for forty years and being sheriff-substitute in 1796. An excerpt from *The Parish Church of Peebles* by Dr Gunn epitomises the limited assistance that could be administered in acute illness at that time. Writing about the death of Dr Reid, he tells:

On the Monday preceding his death he met the Town Council in good health and spirits, and asked them to an entertainment in the town treasure's, and contrary to his custom continued with them till near two in the morning. During that time he displayed more than ordinary spirits. He was very temperate then as always. When he went home he was seized with a severe illness, and although every assistance in Peebles and Edinburgh was obtained the disease (as he himself prognosticated from the beginning) proved, 'twixt seven and eight on Friday evening, fatal to him. The pain he endured during his short illness was most excruciating, yet his senses and resolution never failed him.

His son John, also a doctor, declined to become involved in public life in Peebles having been advised against it by his father.

Next door to Dr Reid's house was a dingy one-storey building (demolished when the Waverley Temperance Hotel was built), which was the surgery and apothecary of Dr Mungo Park, who worked as a doctor in Peebles for a short time from 1801. He was brought up in Selkirkshire and after medical school in Edinburgh, travelled to Sumatra to study plants. The expedition came to the attention of the African Association, who sponsored him to explore the course of the River Niger. He began his journey in 1795 at the mouth of the Gambia River and then on into the Senegal River basin and eventually reached Silla in the Niger Valley. However, he encountered great difficulties, including being kept captive for four months by an Arab chief, and although he escaped, the adventure was aborted due to lack of supplies. While making his way back, he fell ill and was cared for by a local man for seven months. He and his wife, who was the daughter of a Selkirk physician, came to live at a house in the Northgate (recognisable by the fluted columns edging the entrance) in 1801 accompanied by a Morrocan man called Sidi Ambak Bubi, who he had met in London through Sir Joseph Banks, co-founder of the London Linnean Society and who was teaching Arabic language to Park. It was probably the first time the residents of Peebles had seen a Muslim, or even a person of another colour, and

must has been fascinating for the town. Despite the hardships and danger experienced in Africa, Mungo Park could not settle in Peebles and found life there hard and tedious. It seems that exploration, rather than medicine was his calling and when invited to return to the Niger Valley, he accepted and left the town in 1804. The following year he sailed to West Africa on his second attempt to explore the Niger Valley but he did not return and was presumed drowned. The legacy left by this thirty-five-year-old man was firstly a book, published in 1799, *Travels into the Interior of Africa* but more importantly he was the catalyst for a wider interest in the continent.

In 1801, the distinguished Scottish Lieutenant-General Sir Ralph Abercromby led the British Army to victory over the French at the Battle of Alexandria, after which the Rosetta Stone was brought to Britain. One of the principal medical officers in that campaign was Dr Thomas Young, who retired to Peebles to live in Rosetta House, a property he had built in 1806 on land to the north of Ludgate in the Old Town, known then as Acrefield. At that time, there were thatched cottages in Ludgate, but few properties along the route to Rosetta House. However, in the 1880s the town began to expand in this direction and was given the name Rosetta Road and Ludgate was changed to Young Street. Inside the hallway of the property is a replica of the Rosetta Stone; these were fashionable after the discovery and are now available in resin! Curiously, a carved stone head, thought to be seventeenth or eighteenth century, is built into the west wall of the walled garden, but nothing more has been learned about it. The original Rosetta Stone is in the British Museum, although Egypt has repeatedly requested that it be returned. The granodiorite stone is inscribed with a decree issued during the reign of King Ptolemy in 196 BC written in three languages. Confusingly, another Dr Thomas Young, who was alive at the same time as the man in Peebles, and a polymath, studied Egyptology and contributed to the deciphering of the hieroglyphics on the stone.

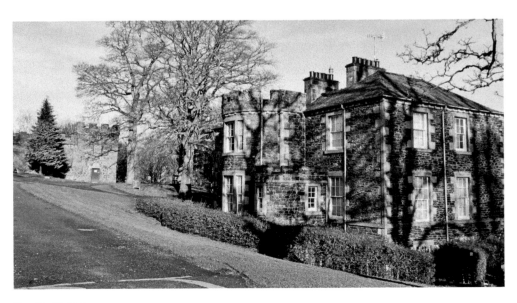

Rosetta House.

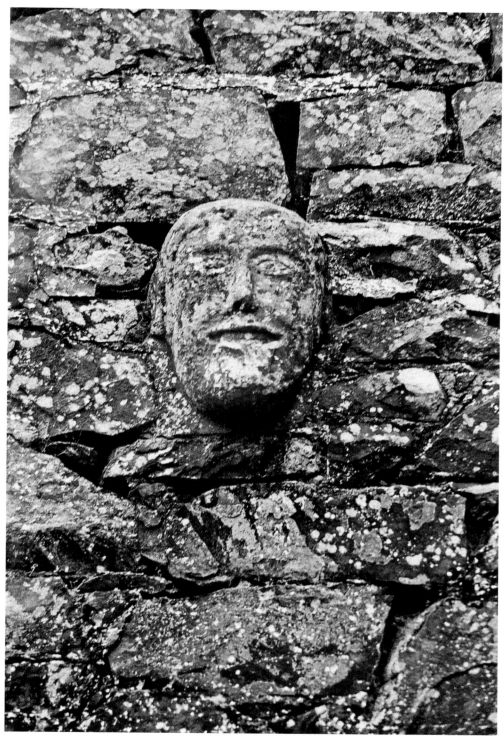

A face in the walled garden of Rosetta House.

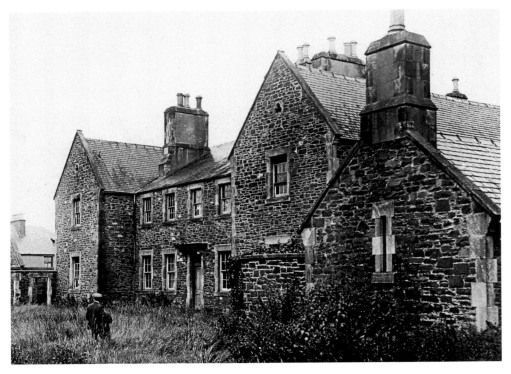

Union Poorhouse. (From the Collections of Scottish Borders Council, administered by Live Borders, Tweeddale Museum and St Ronans Wells.)

A postscript to the Napoleonic Wars was the arrival of around 100 officers from Europe who were prisoners of war stayed in Peebles for a year. The medical men among them were willing to help the local doctors when required.

By the 1860s, life in Peebles had markedly changed for the better. It had its first woollen mill, the railway line to Edinburgh had opened, many new houses had been built and the population had increased from 1,480 in 1791 to 2,045 in 1861. There were many improvements but a cholera outbreak in Britain precipitated a review of the local water supply and the towns' sanitation. Poverty still existed and a decision was taken to build a poorhouse in Rosetta Road, which was completed in 1857 and known as Peebles Union (or Combination) Poorhouse. The snappily named *Peebles County Newspaper and General Advertiser* gave a glowing account of it the following year from which a few extracts have been taken:

The Union House is decidedly the best that we have ever seen. We have visited 3 of these houses in Scotland and some 6 or 7 in England, but this one is infinitely superior to them all. Unlike the red glaring brick buildings in the South, which present a heavy dull aspect to the eye, the Union at Peebles is a sound, substantial and ornamented building, beautifully situated in the valley of Eddleston Water and is decidedly more an ornament to the locality than otherwise .It has a fine and imposing effect when viewed from the railway or from the road to Edinburgh, and the internal accommodation

is as commodious and comfortable as the external appearance is pleasing and imposing ... The two things that struck us most forcibly were the comfortable accommodation provided for the inmates, and the abundance of pure air in all the rooms. As for the dormitories, with their high ceilings and ample space, we unhesitatingly say that there is not a finer view from any bedroom in Peebles. The eye rests on green fields, distant hills and umbrageous woods; and we all know what effect these have on the health and spirits ... we have the kitchen and scullery with their culinary appliances of boilers, dressers, presses, plate-rails etc; the larder, with a range of girnels or binns for flour, meal, barley, peas etc, and wood and stone shelving, the master and mistress rooms, with presses for clothes, linen, bedding etc; a store room, replete with shelving etc, dayrooms with tables, seats with arms, hat pins etc. and the dormitories with neatly wrought iron bedsteads, supplied with comfortable bedding and mattresses filled with cocoa-nut fibre.

These descriptions give an insight into the lifestyle of the era. During the First World War, the premises was made available to the military; a few years later, the establishment had become underused and was shut in 1919. The County Buildings, now Tweeddale District Council Offices and Police Station, erected on the site in 1936 incorporate parts of the original poorhouse.

Peebles has been fortunate to be home to some excellent authors (R. Renwick, William Chambers, J. W. Buchan, Revd Williamson, John Buchan and recently J. L. Brown and I. C. Lawson) who have been inspired to write detailed histories of both the town and the county. One man who not only left a legacy of publications but who contributed so much to the community was Dr Clement Bryce Gunn. He came to Peebles in 1885 from Newburgh in Fife where he had completed his traineeship after graduating from Edinburgh. It was six weeks after opening the practice before his first patient arrived, and even then she didn't settle her dues! Doctors were on duty twenty-four hours a day and travelled by pony and trap or even on horseback (Dr Gunn replaced this mode of transport in 1900 with a motor tricycle). The distances and topography of Peeblesshire made for some dangerous and very uncomfortable visits to remote parts, particularly in inclement weather, anecdotes about which he relates in his *Leaves from the Life of a Country Doctor*. He had met his future wife while ice skating on Lindores Loch, near his Fife practice, and after they were married, gave that name to the house they built at the top of Old Town on the corner of Young Street. He held his surgery here for almost fifty years during which time he came to be loved and respected by the Peebleans. He was a caring, compassionate doctor, taking a keen interest in the poorhouse and was delighted when a Queen's Nurse was appointed there in 1893. Also, he never failed to be moved by the way that the poor in the community cared for one another. He was devout churchman, but beyond this he was passionate about the churches themselves and their history. Despite his medical commitments, he managed to write books about each of the county parishes – *Books of The Church Series* – and although not all of them had been published when he died in 1933, the remaining ones are in the National Library of Scotland. One of these ecclesiastical histories is that of the Cross Kirk, a place that was precious to him. He fought tirelessly for it to be preserved and there is a plaque on one

68

of its walls acknowledging his dedication to that cause. The Boer War (1899–1902) and the First World War occurred during his lifetime and he was responsible for creating a commemorative board, which he crafted himself, naming local soldiers killed in the former conflict. This now hangs in the Ex-Serviceman's Club in School Brae. Books of Remembrance for Tweeddale, Burgh and Parish of Peebles and West Linton, for those lost in the First World War, were also written by him. His contribution to Peebles was truly remarkable and in 1922 he was awarded the honour of Freedom of the Royal Burgh of Peebles.

A fever hospital with twenty beds was erected in the 1890s opposite the poorhouse, albeit constructed with wood and corrugated iron. Infections such as diphtheria, scarlet fever in children, were highly contagious. These were thankfully eradicated with the advent of antibiotics in the twentieth century and the hospital was latterly used for long-term care of the elderly before it was demolished in 1984. The Rose Park sheltered housing complex now stands on the site. Tuberculosis was also a killer and there was a small sanatorium at Caverhill in the lower reaches of Manor Valley. A doctor from the Royal Infirmary in Edinburgh, who subscribed to the 'fresh air' therapy for TB, used to attend the hospital. Remarkably, his name was Dr Francis Spittal Caverhill and he lived in Manor Place in Edinburgh. He died in 1910, thirty-three years before streptomycin was discovered.

During both world wars, large properties were requisitioned for hospital use, including Peebles Hydro, Venlaw Castle and Kingsmeadows House The latter was used for as a maternity unit in the Second World War, both for Peebles residents and for patients from

'Lindores', the house and surgery of Clement Bryce Gunn.

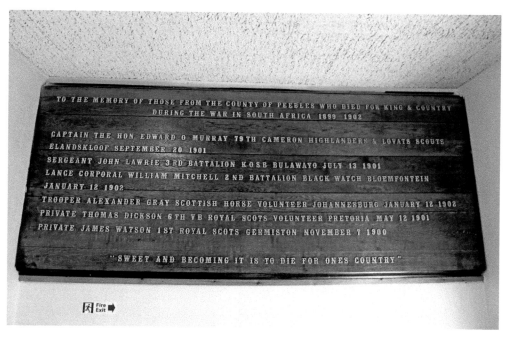

Memorial to Peebleans who died in the Boer War. Made by Dr Gunn.

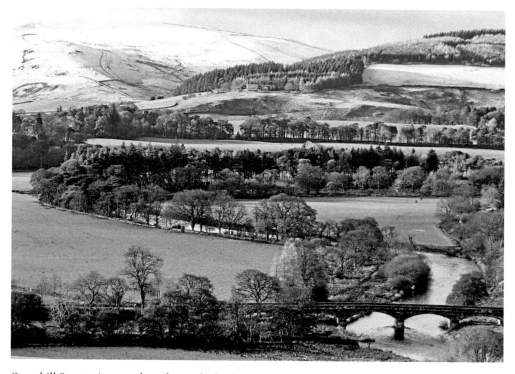

Caverhill Sanatorium on the ridge in the background.

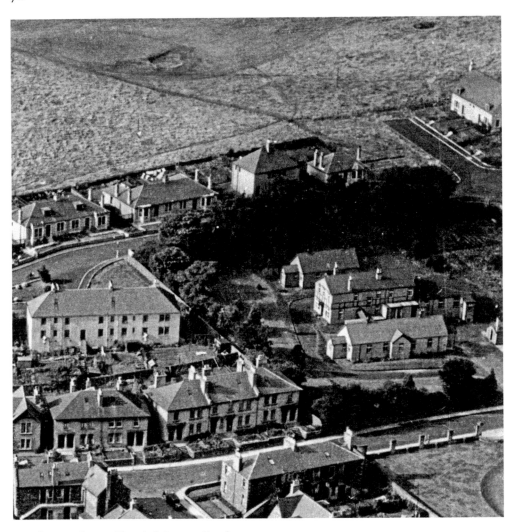

Aerial view of Fever Hospital, Rosetta Road.

Glasgow; many of the adults from the city who began their lives in Peebles have returned to see the lovely house in which they were born. The Peeblesshire branch of the Red Cross was invaluable during these times. Mr D. S. Thorburn had organised a fundraising campaign, which enabled the Red Cross to rent the large house on Tweed Green called Morelands as an auxiliary hospital, run by local GPs (at that time, Dr Henderson, Dr Marshall and Dr Wilson). In 1922 this property was combined with two others to create the War Memorial Hospital. Since Hay Lodge Hospital and Health Centre were built, it has been used as a nursing home but is currently undergoing repairs after the big flood of 2015.

Crime and Punishment

A great deal can be gleaned about social conditions of any given era by the types of crimes or misdemeanours committed and the sentences imposed. It is uncommon to see a policeman walking the streets in the twenty-first century, in part due to politics, but more because of computer-based operations – so much investigation is carried out remotely. Prisons in Britain are currently bursting at the seams but imprisonment wasn't always the chosen method of sentencing. The constabulary in Peebles began in 1840, primarily to deal with the waifs and strays on the streets. The population was 1,908 in the 1841 census but double that number of vagrants and beggars were visiting the town each year – an indication of the widespread poverty that still prevailed. Up to this point, action against lawbreakers was rather haphazard with one man, known as 'the hangman or deputy executor of the law', who was authorised to whip offenders or lock them without keeping any record of the case. The procurator fiscal complained to the Justices of the Peace about the inadequacy of the system and this action, combined with the problem of aforementioned homeless persons, resulted in appointing one superintendent, one constable and five others stationed in other parts of the county – the beginning of the police burgh.

The first burgh records in Peebles date from 1456 and from these it is apparent that fines were the order of the day and that the council relied on this revenue to bolster the funds necessary undertake their municipal duties, the most frequent and important of which was maintaining and repairing Tweed Bridge. A typical case would involve a resident, or even a burgess, leaving their midden on the street for more than four days, which incurred a payment of 8s. That situation continued for centuries – by 1719, the dung heap had to be removed within forty-eight hours and the fine had increased to 40s Scots. Livestock issues frequently arose too and examples of fines were as follows: for pigs running amok in the street, 8s; or geese eating the grass on common ground, 40d per goose. Hens were prone to roosting on the thatched roofs, causing damage, and although the council condoned killing the offending fowl, neighbours did not take kindly to this approach, so a bizarre, but probably effective deterrent was conceived whereby a heavy piece of wood was attached to the hen's foot preventing the bird from being able to take off! It is worth mentioning at this point animals were slaughtered in the street until the early seventeenth century, when a fleshmarket was erected next to the old tollbooth at the foot of Briggate (Bridgegate). This property was sold a few years later and another built off Deans Wynd on the High Street. This medieval slaughterhouse was used right up until 1895, when a more hygienic one was built at Southparks on the outskirts of the town. The entrance can still be seen from the wynd where one stone stall is standing; the killing enclosure is extant too, although private property, and the central metal tethering ring and channels for the blood to flow away

Old slaughter house.

are gruesome reminders of the crude method of slaughter. A vigorous rambling rose adorns one of the walls!

In the sixteenth century, seemingly petty actions could be disciplined. In 1560 playing football was forbidden in the street and guilty individuals were fined and had the ball destroyed; in 1572, a penalty was imposed for climbing over the newly built town wall. However, by the early 1600s regular infringements such as drunkenness, theft and brawling were overshadowed by more serious lawbreaking in the county as several local families became particularly troublesome feuding among each other. There was tension between the Stewarts of Traquair and the son of Lord Hay of Yester (nicknamed Wood-Sword), let alone the Burnetts of Barns, the Horsburghs, the Gledstanes and Scotts, noted for disputes regarding grazing rights on Cademuir, but none were more notorious than the Tweedies of Drumelzier, aided and abetted by their relatives at Dreva, Wrae, Stanhope and Fruid. They particularly targeted the Veitches of Dawyck and the Geddes family of Rachan in a long and hateful vendetta, which included committing the unprovoked murders of William Geddes in 1559, Patrick Veitch, who they ambushed near Neidpath Castle in 1590, and James Geddes in 1592, having hounded him in Edinburgh for eight days before butchering him in Cowgate. Members of the latter family retaliated by killing John Tweedie, burgess in Edinburgh. The justice system in Scotland left a lot to be desired under James VI, who ordered the guilty parties to be released from the Tollbooth in Edinburgh, which merely enabled them to continue their brutal feuds. They slipped

through the judicial net many times, evading justice, until their past finally caught up with them. The family had accrued so much debt that they were forced to sell off their land and properties, while the last criminal member lay destitute in the Tollbooth in Edinburgh. Walter Scott wrote about the issue in his introduction to *Minstrelsy of the Scottish Borders* in 1802:

> Veitch of Dawyck, a man of great strength and bravery, who flourished in the 16th century was upon bad terms with a neighbouring proprietor, Tweedie of Drumelzier. By some accident, a flock of Dawyck's sheep had strayed over into Drumelzier's grounds at a time when 'Dickie of the Den', a Liddesdale outlaw was making his rounds in Tweeddale. Seeing this flock of sheep, he drove them off without ceremony. Next morning, Veitch perceiving his loss, summoned his servants and retainers, laid a blood-hound upon the traces of the robber, by whom they were guided for many miles till, on the banks of the Liddel, he staid upon a very large haystack. The pursuers were a good deal surprised at the obstinate pause of the blood-hound, till Dawyck pulled down some of the hay and discovered a large excavation, containing the robbers and their spoil. He instantly flew upon Dickie, and was about to poniard him, when the marauder protested that he would never have touched a cloot [hoof] of them had he not taken them from Drumelzier's property.

The story also illustrates the crime of reiving that prevailed across the Borders from the fourteenth to seventeenth centuries.

The lawlessness of these times, together with bickering (and sometimes corrupt) burgesses, feuding landowners and weak judicial process, was a dark period for Peeblesshire. The building used to lock up offenders was the ubiquitous tollbooth, found in every town. It is widely agreed that the medieval tollbooth in Peebles was at the foot of Briggate, on the right-hand side opposite Tree Bridge. However, by the early 1600s, it was falling into disrepair and was barely secure enough to confine prisoners, so an alternative location was needed. The Steeple, a defensive tower built in 1490 as part of the chapel 'complex' at the west end of the High Street, was being employed as a jail too but likewise was not completely secure. Tollbooths were multipurpose venues, being used for council meetings and court sessions as well as incarceration and the situation regarding imprisonment in Peebles did not get resolved until the eighteenth century when a Town House and proper jail were built, and the Steeple was demolished in 1776. An interim arrangement was made when the council purchased a house in the High Street for £20 from Lord Elliok, which had two vaults below ground for prisoners. However, the gratings on the street allowed locals to hand drink or other indulgences through to the criminals and the premises were deemed unsatisfactory and sold in 1798 for £200 more than the original cost. This is now Walters the jewellers.

The Steeple was furnished with the town clock and two bells and manned by a keeper. He was required to keep the timepiece wound and to ring the bells at 5 a.m. and 8 p.m. in addition to keeping an eye on the prisoners. When the new parish church was built in 1778, the council insisted that the clock and bells from here were transferred there and remain their property ad infinitum. The chimes of this clock, heard every fifteen minutes,

A medieval defensive tower called the Steeple, depicted on a burgess ticket.

is the only continuum of that era, as nothing is left of the steeple but foundations and vaults under a dwelling in Parliament Square.

The church, as noted in a previous chapter, was administering strict discipline of its own in a desperate attempt to control people's behaviour, but the burgh records are filled with cases of brawls and fights for which the culprits were usually fined up to £10 Scots; swearing or verbally abusing an official incurred a 40s fine. Parents of children caught stealing fruit from orchards had to pay £5 Scots. The council laid down harsh rules regarding their meetings too. In 1632 missing a session without a valid excuse warranted a fine of 8s Scots, whereas those who were late or left early were charged 2s. The Act was renewed in 1688 when offenders were put in prison until the fine was paid. Towards the end of the century, the church took an even greater 'policing' role, whereby elders were expected to enter alehouses to search for drunkards or anyone found imbibing after 9 p.m.

Jurisdiction had been under the auspices of noblemen who inherited positions of High Sheriff, usually with no qualifications to perform the role, while the real sheriff, his deputy, was preoccupied with the collection of feu duties and administration, with the result of a grossly ill-served community. Reform came after the 1745 rebellion, when hereditary offices were abolished and experienced advocates were appointed by the Crown, and a resident magistrate chosen by his deputy. The first sheriff-depute for Peeblesshire was Mr James Montgomery, who became Lord Advocate in 1766, MP for Peeblesshire in 1768 and ultimately rose to Lord Chief Baron of the Exchequer of Scotland. He owned Stanhope estate, then Stobo, whose policies he planted and cultivated in support of agricultural improvement. His son, James, built Stobo Castle in 1805 and continued the woodland planting started by his father. The Japanese Water Garden was not created until the early twentieth century, and the primary purpose was to harness the water power to generate electricity.

The above reforms marked a turning point, not only for Peebles but for the whole country as the new century approached and much greater social changes were to happen. Crime did not stop of course, but the violence and turbulence of preceding times were laid to rest. The following transgression, reported in the burgh records for 1797, was somewhat milder: 'Ordered that all boys pulling up stones in the street with suckers are to be seized and their suckers taken from them.' There was also the case in 1907 when a motorist was fined £5 for exceeding 10 mph.

The new constabulary of 1840 was based at a house on Port Brae, where it is just possible to make out the words 'POLICE OFFICES' above the door. In 1887, they transferred to a larger house next door, built that year, where they remained until Peebles Police Station was added to the County Buildings in Rosetta Road recently. The *Peeblesshire News* of 17 February 2017 published an article from which the following extracts are taken:

A Borders councillor is calling for more bobbies on the beat to curb the escalating problems of anti-social youths in town centres.... Councillor Sandy Aitchison, who is responsible for education at the local authority, believes patrolling policemen is the answer. He said: 'In my day we were all frightened of the bobby coming round the corner and catching you. You don't see the bobby any more-youths don't have the same fear of getting caught that previous generations did.'

Police office, opened 1840.

Peebles for Pleasure

The above marketing catchphrase was used in the late twentieth century and appeared on an advertising board for Peebles Hydro at Leadburn Junction. However, the origins stemmed from a much earlier time when a poem 'Peblis to the play' was credited to James I, who was crowned in 1424. What is not in doubt is that medieval royalty frequently visited Peebles, not only to hunt in the old Caledonian woods of Ettrick Forest to the south but to enjoy the rural sports day of Beltane, held at that time on 1 May. At the beginning of the 1600s, Peeblesshire was riven with violence and feuding between local lairds and such was the disruption that the festival was cancelled in 1608 and did not restart until 1662, after the restoration of the monarchy two years earlier. It is believed that the metal weathervane, bearing this date and crowning the Mercat Cross, was made to celebrate the rebirth of Beltane. The horse racing took place on Whitehaugh Muir, having been run in earlier times between Eastgate and Nether Horsburgh, but this location too was lost after Dr James Hay of Kingsmeadows began enclosing and planting on his estate in 1760s. The tradition of Riding the Marches was eventually started again in 1897, the year of Queen Victoria's Diamond Jubilee, when Sir John Hay of Haystoun also gave an area of his estate to the town-appropriately called Victoria Park. Two years later, a Beltane Queen was chosen and since that time, the festivities have been continued as a week of celebrations attracting large numbers of visitors. Other fairs were held throughout the year, but gradually dwindled away as their purpose, generally to hire farm labour, became redundant. One such was Fasten's E'en Fair held on the first Tuesday of March and another was the Wool Fair in July.

The other pastime in the Middle Ages, an era where there was very little leisure time, was archery, which took place on Tweed Green and Venlaw. In 1628 a silver arrow was bought to present to the winner of a competition being held in May. The prize was around 15 inches long, and each year a silver medal was engraved with the name of the winner and hung from the shaft. Towards the end of the seventeenth century, religious and political turmoil disrupted life in Scotland and no more is heard of the archery competition or the arrow in burgh records until 1780, when the Steeple and chapel were demolished and the silver arrow was found in the rubble, presumably having been hidden in a safe place. The trophy is now kept at the Royal Company of Archers in Edinburgh.

In medieval times, there were alehouses in the burgh but the church exercised a strict moral code regarding drinking, typified by these Kirk Session records: 8 May 1691, 'It is recommended to the different elders to search in their quarters if any have carried themselves scandalously in time of the fair, that either they be punished accordingly, or banished the town. It is also ordered that a deacon and an elder, with the beadle, go through the town after the afternoon-sermon at 6 o'clock and search all the suspicious alehouses for drunkards'; from November 1698, 'The elders, along with the kirk-officer

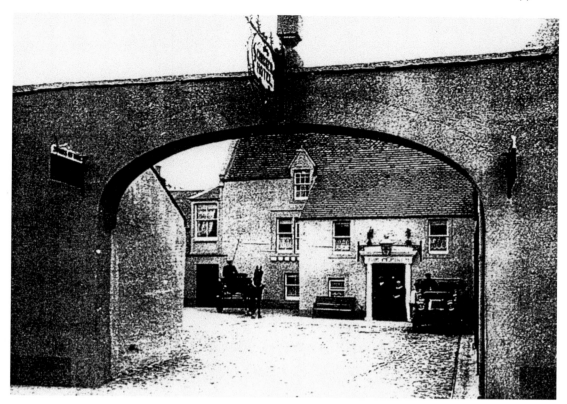

Cross Keys Inn, previously called The Yett.

are appointed to scour the town for vaguers on the Lord's Day. Anyone found drinking in an alehouse after 9 p.m. to be censured'.

The first inn, The Yett, was established in the mid-1700s. The house in the Northgate had been built in 1653 by Walter Williamson of Cardrona, who appeared to be a property speculator of his day, to use in the winter as a town house.

It was run by a Mr Ritchie, succeeded by his daughter Marion, who became well known in the burgh for her feisty manner and firmness in refusing to serve customers who had overindulged. It is widely known that she influenced Walter Scott when he created the character of Meg Dods of the Cleikum Inn in his novel *St. Ronans Well*. The hostelry has served the Peebles community well for 300 years but recently the fabric of the old building started to disintegrate and the hostelry was closed, a novel and sad sight. However, Wetherspoons purchased and renovated the inn, which has now reopened and has retained the tradition of letting rooms. Back in 1808 Miss Ritchie's monopoly was challenged when the Tontine Hotel was built in the High Street – she and her sister apparently turned their heads the other way when walking past it to attend church. The construction would have involved clearing several houses and their gardens, which sloped down to Tweed Green, in order to accommodate the hotel, coach house and stables. The tontine was a concept started in the seventeenth century by an Italian banker,

Lorenzo de Tonti, whereby capital was raised for a project by subscriptions from a group of people, who received payments annually; the shares rose as contributors died and the last survivor took all that was left. This method of fundraising fell out of favour in the nineteenth century, but £3,950 was raised to pay for the new hotel, which was completed in 1808. The first manager was Frenchman Monsieur Lenoir and when he died, his wife divided the interest between the remaining 'shareholders'. The splendid ballroom proved to be immensely popular because prior to this, only a small one was available in the Northgate near the top of Ushers Wynd. This is now used as a dining room but retains the original plasterwork and gallery with ornamental iron railings.

DID YOU KNOW?

The Cross Keys Inn in the Northgate was built in 1693 as the winter town house for Walter Williamson of Cardrona. The slates are arranged to create 'WW' on the roof – the seventeenth-century equivalent of personalised number plates!

Around this time, Peebles received around 100 prisoners of war, including French, Italian and Polish complementing the small group of Dutch and Danish that had arrived in 1803. During their twelve-month stay, they embraced the spirit of the community and performed plays for free in the upper room of the Town House.

Life changed exponentially for the burgh of Peebles by the end of this century, propelling the quiet county town into a bustling metropolis. The two mills at Tweedside and Damdale were joined by a third, March Street Mills, built by David Ballantyne & Co. in 1885, adding to the burgeoning population and ancillary businesses, but the opening of the railway lines to both the east and west, as well as Edinburgh, brought a new dimension to the town – that of the tourist. Several small hotels had been established since The Tontine, including The Damdale, which was convenient for the mill, but the grand edifice of Peebles Hotel Hydropathic, which opened in 1881, was on a different scale. The architecture was French Renaissance in style, the five storeys and their towers looming up from the south side of Venlaw Hill, creating a stunning landmark and commanding beautiful views across the Tweed Valley. The cost was over £80,000 and they had their own water supply from Soonhope Burn to satisfy the Victorian belief in the therapeutic properties of 'the waters'. The establishment proved to be a major attraction for Peebles, but unfortunately a massive fire in 1905 razed it to the ground. It is remarkable that the present Peebles Hydro was built within two years of the disaster. The first Hydro was built with red sandstone from Dumfriesshire (the foundation stone was laid by Dr William Chambers of Glenormiston) and the unusual colour of this material can still be seen in the gate piers at the entrance off Innerleithen Road, which were obviously too far away to be affected by the blaze.

The temperance movement was also a fashion of the Victorians and two 'hotels of abstinence' were built on the south side of the High Street opposite Northgate. Part of the Temperance Hotel was on the site of Mungo Parks' old apothecary.

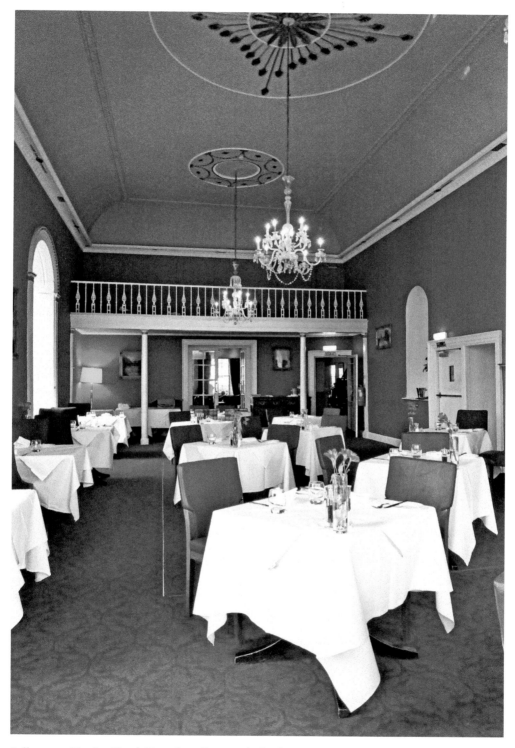

Ballroom at Tontine Hotel. Note the gallery on the back wall.

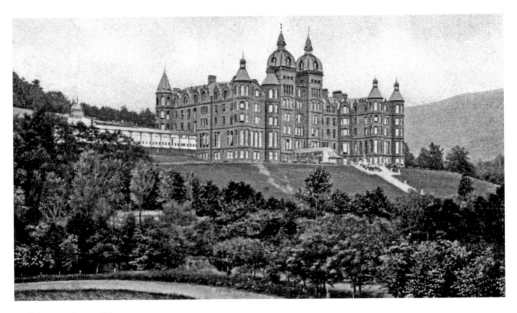

Peebles Hydropathic, 1904.

Gate pier of the original Hydropathic.

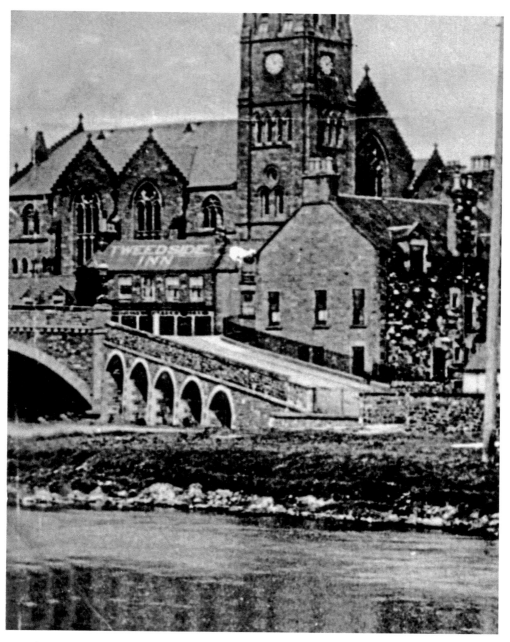

Tweedside Inn, demolished during the bridge widening of 1899.

The Minister's Pool, known locally as Minnie's Pool, is a stretch of the Tweed below the old parish church manse and was a favourite location for swimming. In 1907 an aquatic carnival was held there, which attracted large crowds keen to learn about life-saving and watch demonstrations of other sports like water polo. The success of the event

Minnie's Pool.

Site of the Dookits.

highlighted the enthusiasm for swimming and the need for an indoor pool, a cause taken up in 1919 by Sir Henry Ballantyne, who offered to underwrite the cost. The baths were made in an existing building at the lower left-hand corner of Tweed Brae that had been built originally in 1791 as the United Presbyterian Church. It then became a temporary home for the Drill Hall until a permanent one was erected in Walkershaugh in 1898, and in 1904 was used as a car workshop for the Peebles Motor Co., run by Laurence Bell. This engineer had worked in Asia prior to starting a small business in Peebles from which he accomplished a great deal, including being the first person in the Borders to build a car from scratch in 1901 – a true pioneer.

Despite the invaluable gift from Henry Ballantyne, outdoor swimming remained tempting for some hardy souls and on a rock at the entrance to Neidpath gorge are the metal remnants of a diving contraption known as the Dookits. The new swimming pool on the site of Tweedside Mills opened in 1984.

The traditional and most elemental sport of curling has been played for centuries and it is probably an indication of climatic change that the rinks of old were in natural declivities where the water was frozen for weeks or months; the last time a Grand Match was held outdoors was in 1979 at Lake of Menteith. Peeblesshire had curling ponds at Tweedsmuir, Wrae Pond at Rachan, The Glebe in Broughton, Bells Pool at Dawyck, at Lyne Water where it joined The Tweed, Horsburgh Loch, The Glen, Howford Pond, Traquair House grounds, Innerleithen and West Linton. The site favoured in Peebles was the Gytes,

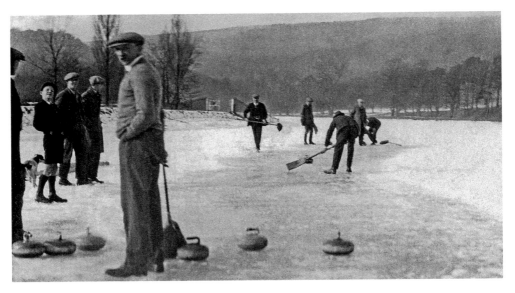

Curling on the Tweed.

which flooded naturally, although Cuddy's Pool is also referred to. Peebles Curling Club was founded in 1821 and the (courteous) rules were laid out as follows:

Every member shall be able to prove himself the lawful owner of at least one stone.

The number of stones to be played at any particular time shall be determined by the whole body when members are all standing ready for the game.

When ladies come near the rink and are disposed to play, the skips shall have the privilege of instructing them to handle the stones agreeable to the rules of the game.

When a member falls and is hurt, the rest shall not laugh but render him every assistance to enable him to regain his former erect self.

When the club according to use and want, beat their opponents they should not exult too much so as to wound the feelings of a fallen foe but consider the victory merely as a chance of war.

Every member shall also provide himself with a broom and a pair of trickers.

The club shall dine annually by subscription on the 13th day of January, the expense of the dinner and drink not to exceed 2/6d and any member subscribing and not attending the dinner is to forfeit 1/-.

The club dinner will be restricted to beef and greens and whisky toddy.

There is an extract from the Peebles Curling Club minutes of January 1821 that poetically describes the sport, participation in which was possibly the only advantage of long cold winters:

At the season of the year when the plough is arrested in the furrow, when masonic and many other handicraft implements are laid aside and when the mill wheel refuses

to revolve on its axis, what can be more harmless, what more salubrious, what more social than for those who are in possession of health, endowed with muscular strength, blessed with a keen eye and a steady hand to repair to the still water of Cuddie's pool or the flooded Gytes, the waters whereof are bound in icy fetters, the surface smooth as a polished mirror and transparent as the crystalian cup, and there give a display of strength, dexterity and skill, united in a game, the darling of our forefathers.

A memorable victory for Tweeddale over Midlothian, played at The Whim and Penicuik House in 1823, resulted in two significant events. Firstly, in celebration, Sir John Hay presented the club with a large silver medal, which is still awarded annually. Secondly, the match caused some confusion; fifteen rinks with fourteen men a side took part but each club had slightly different rules, which highlighted the need for an overriding body to preside, hence the founding of the Royal Caledonian Curling Club. Meantime, the club had been using Ninian's haugh on the south of Tweed Bridge, but the coming of Caledonian Railway interfered with the location, so Sir Adam Hay offered the use of his pond in Kingsmeadows ground, east of the present Victoria Park, which was used until 1951 when the council compulsorily purchased the land for house building. Since that time, Peebles Curling Club has used indoor rinks, routinely at Murrayfield.

The ancient game of quoiting took place on Tweed Green, although it could be played anywhere there was space, as in the photograph taken in the railway goods yard. Note the

Curling pond, Kingsmeadows Road.

Quoits game in railway goods yard. (From the collections of the Scottish Borders Council, administered by Live Borders, Tweeddale Museum and St Ronans wells.)

rooftop of Glencorse House behind the wall in which so many businesses had operated over two centuries. Peebles had a quoiting club until 1950, but it was particularly favoured by Innerleithen and was part of St Ronans Borders Games, started in 1827.

Golf, another traditional Scottish pastime, was played in Peebles from 1892 at a nine-hole course on Morning Hill. The following extracts from an article in the *Peeblesshire Advertiser*, 15 April 1893, capture the flavour of that time, and the leading lights in the burgh:

The formal opening of the Peebles golf course and pavilion took place on Saturday afternoon, in presence of a full turnout of golfers and a large number of interested spectators including the Provost and Magistrates of the Auld Burgh, who, preceded by the Constabulary force, headed by Deputy Chief Constable Arrol and the burgh officers in their uniforms, and carrying halberts, marched to the scene of the afternoon's operations. The weather was splendid, the sun shining with great brilliancy during the whole afternoon. The large company assembled in front of the hansom and commodious pavilion. Mr Henry Ballantyne of Minden, the captain of the newly-formed club, said he was glad to see such a large gathering, and this he regarded as an indication that the latest attraction to Peebles, in the shape of a fine golf course, was a great success. He then called on Mr W. Thorburn MP to declare the course open.

The club, he was glad to say started under the happiest auspices. Already there were 21 life members, 93 ordinary members, 28 lady members and 24 boy and girl members, making a total of 166. That, he thought was very satisfactory. Then, as regarding their financial position, the Club had started practically free of debt and so far as human foresight could divine, there was no danger of them getting into a financial "bunker". He was glad to see they had enlisted the ladies as members, for, if necessity arose, they would prove most useful beggars and would be most essential in the case of a bazaar. He was also pleased to see that so many of the artisan classes were members, for in such games as bowling, curling and golfing, a healthful recreation would be found and in which all classes of the community were brought together... The course, of which we give a sketch, is on the Morning Hill on the farm of Edderston and about a mile distant from Peebles. It belongs to the Earl of Wemyss and March who has very handsomely leased it to the Golf Club on exceedingly reasonable terms.

Photographs were then taken by Messrs McNaught & Son, Peebles. The popularity of the club led to this course being deemed too small, so a new eighteen-hole plan was laid

Pavilion of the nine-hole golf course, Morning Hill, 1893.

out on ground at Kirklands. This also belonged to Wemyss and March estates but was purchased by the town council, along with adjoining land at Jedderfield, Hay Lodge Park and Eliots Park, between 1918 and 1919, partly due to the acute need for new housing. The clubhouse was rebuilt in 1998 and opened by HRH Prince Andrew, Duke of York, although further alterations have been carried out in the year of writing – 2017 – creating a state of the art meeting place in contrast to the utilitarian 'hansom and commodious pavilion' of 1892. The panoramas from this course are, in the humble opinion of the author, the most breathtaking in the Borders.

Golf clubhouse at Kirklands.

Arts, Crafts and Trades

The preceding pages have described some of the buildings and people of the past, but history is of course a continuum and noteworthy structures have appeared in Peebles in recent times and reflect changing fashions and styles. Behind them lie the skills and creativity of artists, craftsmen and tradesmen, a few of which are featured in this concluding chapter.

Local whinstone, from which many buildings in Peebles are constructed, was always reused after demolition, so it is pleasing to learn that the new life-size sculpture below Venlaw is composed of recycled horseshoes. Scott Brash MBE, a native Peeblean, won a gold medal for show jumping at the 2012 Olympic Games and the statue commemorates himself and his horse, Hello Sanctos, four of whose horseshoes are incorporated. The sculpture was crafted by blacksmith Kevin Paxton of ARTFE in Edinburgh and paid from money raised by the community group Bonnie Peebles.

Kingsland Primary School moved from the Victorian building in Rosetta Road in 2010. The new location is at Neidpath grazings, making it the first building to come into view when approaching Peebles from the west and, as such, the visual impact was a major consideration. The architectural design, together with sympathetic use of wood and

Scott Brash sculpture.

Kingsland School.

local stone, has made for an attractive structure, which was chosen as Building of The Year in 2011 by Edinburgh Architectural Association. Inside the school is a stained-glass panel incorporating the Callants Club badge. The front entrance wall is decorated with a contemporary interpretation of the Peebles Arms, using the phrase 'Deeds not words', which was favoured by William Chambers and is included and beautifully sculpted by Ruaraig and Iomhar McIvor of Beltane Studios, who also made the fish fountain outside Eastgate Theatre.

The skilled masonry work in Peebles was often done by Clyde the builders, who were responsible for widening Tweed Bridge by 21 feet in 1898 and constructing the plinth on which the Market Cross is placed, but sadly the business no longer exists. Mitchell the painters on the other hand have been serving the local community since 1790. When their premises were below the Caledonian Railway Hotel, they went to great pains to have innovative window displays, but in the early 1900s they stepped over the line; having commissioned a banner featuring cherubs in each corner, it was proudly hung in the window on the High Street but was soon discovered that the 'bare bottoms' offended Victorian sensibilities and it had to be removed after only one day! The business is now owned by Thorburns, whose workshop, mentioned earlier, is tucked away down a close off the High Street, where the office door has an eye-catching design advertising, among other tasks, 'bell-hanging'. The paint store is a work of art in itself – rather like

a tradesman's Jackson Pollock among little metal mixing buckets – and the Rules of Employment board from last century includes 'No5. Employees must be on their job at specified hours for starting if said job is within 1 mile of the Cross'.

Right: The offensive cherub.

Below: Painters workshop.

Painted stairs, Castle Warehouse, Old Town.

The Castle Warehouse has been trading in the Peebles since 1896, when it was opened by George Anderson, who had been an apprentice with Whities the drapers. He went into partnership with Mr Findlayson in 1915 and the business has been in that family ever since, having expanded several times over that period. In the 1990s the grandsons, Ian and Sandy, decided to brighten up the three-storey stairwell next to their Old Town shop with floor to ceiling murals depicting different corners of the world, starting with a Peebles townscape on the ground floor. The artwork, done by Alan Liversedrge, took about two years to complete.

One of the old houses in the Northgate is used as an art gallery by Moy Mackay, who creates vibrant landscapes from felted wool fibres, which have been praised by Kaffe Fassett. She has drawn inspiration from the Tweed Valley, where she has lived and worked since graduating from Glasgow School of Art in 1990. Last year she submitted her work *The Cuddy* to a national competition run by Sky Arts Landscape Artist of The Year, where she was short-listed to the final three. Her reputation is worldwide and she recently received a commission from the Falkland Islands.

The stained-glass portrayal of Peebles, by artist Liz Rowell, is in a private house and reflects the beauty of the town that has seen dark times but has survived to become a flourishing and attractive place to both live and visit.

Moy Mackay Gallery, Northgate. (Photograph courtesy of Moy Mackay)

The Cuddy by Moy Mackay.

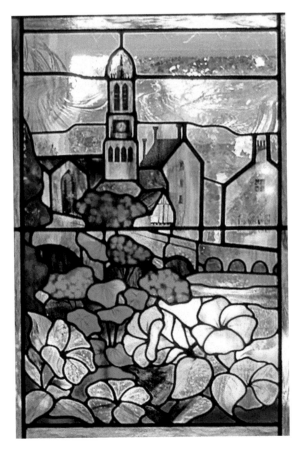

Stained-glass door panel by Liz Rowell.
(Photograph courtesy of Maureen
Samson)

Acknowledgements

I am particularly grateful to Douglas Whitie and Stuart Akers for giving me so much of their time and historical knowledge, and to Donald Swanson, Roger Scott and Maureen Sansom for letting me use their photographs. Thank you to the following people for their contributions and assistance: the staff at Tweeddale Museum, Ian and David Thorburn, Michael Ireland, Willie Baird, Jan Haydock, George Futers, MAPA Scotland, Ian Finlayson, John McOwan, Mary Smith, Donald Culbertson, Jim Lyon, Bill Goodburn, Karl Napier, Kenny Bauld and Alan Mawer.

Bibliography

A History of Peeblesshire by William Chambers

Borders and Berwick, An illustrated Architectural Guide to the Scottish Borders and Tweed Valley by Charles Alexander Strang

Glimpses of Peebles by Revd Alex Williamson

History of Peebles 1850–1990 by J. L. Brown and I. C. Lawson

History of Peeblesshire by J. W. Buchan MA, LLB

Leaves from the Life of a Country Doctor by Clement Bryce Gunn

Memoir of Robert Chambers with Autobiographical Reminiscences of William Chambers by W. Chambers

Ordnance Gazeteer of Scotland by Francis H. Groome

Peebles Beltane Festival, Jubillee Book

The Buildings of Scotland-Borders by Kitty Cruft, John Dunbar & Richard Fawcett

The Cross Kirk Peebles by Steve Dube

The Parish Church of Peebles by Clement Bryce Gunn